LEGENDARY LOCALS

OF

LOWELL

MASSACHUSETTS

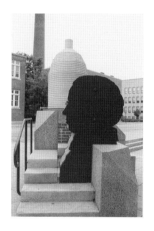

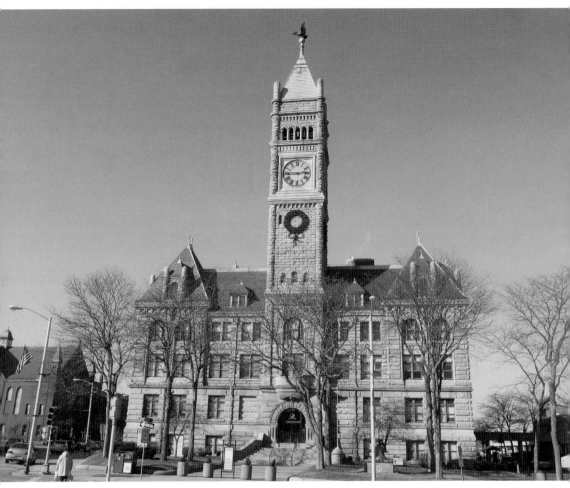

Lowell City Hall
Constructed in 1893 at a cost of $300,000 on land purchased from the Merrimack Manufacturing Company, Lowell City Hall is an ornate building filled with oak and marble. Its 360-foot clock tower is visible from all sections of the city. (Courtesy of Richard P. Howe Jr.)

Page 1: Lowell Sculpture One
This six-ton metal silhouette of Francis Cabot Lowell, backed by a mammoth granite thread spool, sits on the edge of Boardinghouse Park in the Lowell National Historical Park. (Courtesy of Richard P. Howe Jr.)

LEGENDARY LOCALS

—— OF ——

LOWELL

MASSACHUSETTS

RICHARD P. HOWE JR. AND
CHAIM M. ROSENBERG

LEGENDARY
LOCALS

Copyright © 2013 by Richard P. Howe Jr. and Chaim M. Rosenberg
ISBN 978-1-4671-0048-9

Legendary Locals is an imprint of Arcadia Publishing
Charleston, South Carolina

Printed in the United States of America

Library of Congress Control Number: 2012944405

For all general information, please contact Arcadia Publishing:
Telephone 843-853-2070
Fax 843-853-0044
E-mail sales@arcadiapublishing.com
For customer service and orders:
Toll-Free 1-888-313-2665

Visit us on the Internet at www.arcadiapublishing.com

*This book is dedicated to Roxane Howe and Dawn Rosenberg
without whose support this project would not have been possible.*

On the Cover: From left to right:
(TOP ROW) Nathan Appleton, industrialist (Courtesy of Longfellow National Historic Site, National Park Service; see page 13), John Lowell Jr., mill owner (Courtesy of *History of the Lowell Institute*; see page 21), Amsi Morales, lawyer and philanthropist (Courtesy of Amsi Morales; see page 95), James C. Ayer, patent medicine creator (Courtesy of *Illustrated History of Lowell*; see page 34), Norman Brissette, Hiroshima casualty (Courtesy of Tony Archinski; see page 87).
(MIDDLE ROW) Phala Chea, school administrator (Courtesy of Phala Chea; see page 61), Benjamin Butler, general and governor (Courtesy of Library of Congress; see page 79), Fru Nkimbeng, African Festival founder (Courtesy of Adrien Bisson; see page 107), Camille Eno, mill worker (Courtesy of Leon Eno; see page 107), Niki Tsongas, congresswoman (Courtesy of Niki Tsongas; see page 91).
(BOTTOM ROW) Paul Tsongas, US senator (Courtesy of Niki Tsongas; see page 100), Mary Sampas, newspaper writer (Courtesy of Marina Sampas Schell; see page 110), David McNerney, Vietnam War veteran (Courtesy of Kathleen Kress Hanson and Eileen Kress; see page 90), Edith Nourse Rogers, congresswoman (Courtesy of Library of Congress; see page 83), Micky Ward, boxer (Courtesy of Kevin Harkins; see page 96).

CONTENTS

ACKNOWLEDGMENTS

We wish to thank the following people and organizations for their support and assistance: Sue Andrews, Peter Aucella, John Boutselis, Emily Byrne, Maria Cunha, John Descoteaux, Steve Dulgarian, Robert Eno, Bill Giavis, Joe Hungler, Peter Kostoulakos, Eileen Loucraft, Brian Martin, Marty Meehan, Chris Mullen, Steve O'Connor, James Ostis, Muriel Parseghian, Tony Sampas, Peggy Shepard, Eric Slusher, Jason Strunk, Germain Trudel, and Kendall Wallace.

We would especially like to thank Erin Vosgien, Kevin Harkins, Paul Marion, Marie Sweeney, Mary Howe, Dawn Rosenberg, and Roxane Howe.

The following sources were used for this book:

Sydney Howard Carney, *Genealogy of the Carney Family* (1904), (CF)

Edwin P. Conklin, *Middlesex County and its People* (New York: Lewis Historical Publishing, 1927), (MC)

Illustrated History of Lowell and Vicinity (Lowell: Courier Citizen, 1897), (IHL)

Richmond Pearson Hobson, *The Sinking of the Merrimac* (New York: The Century Co., 1899), (HOB)

Robert E. Wescott, *Monograph of City Hall and Memorial Building* (Lowell: 1893), (CH)

Charles Cowley, *The History of Lowell* (Boston: Lee & Shepard, 1868), (HOL)

Harriett Knight Smith, *The History of the Lowell Institute* (Boston: Lamson, Woolf, 1896), (HLI)

William Appleton. *Selections from the Diaries of William Appleton, 1796–1862* (Boston, Privately Printed, 1922), (WA)

Memoir of Thomas Handasyd Perkins (Boston: Little Brown, 1856), (THP)

William R. Lawrence, *Extracts from the Diary and Correspondence of Amos Lawrence* (Boston: Gould & Lincoln, 1860), (DAL)

Catalog of the Lowell Machine Shop, Builders of Cotton Machinery (Lowell, 1893 & 1902), (LMS)

Contributions of the Old Residents' Association (Lowell: Morning Main Press, 1884), (ORA)

Biographical History of Massachusetts: Biographies and Autobiographies of the Leading Men of the State, Volume 1 (Boston: Massachusetts Biographical Society, 1911), (MBA)

Daniel P. Toomey, *Massachusetts of Today* (Columbia Publishing Co, 1893), (MOT)

Lucy Larcom, *The Poetical Works of Lucy Larcom* (Cambridge: Houghton Mifflin Co., 1884), (LL)

George F. Kenngott, *The Record of a City* (New York: The Macmillan Company, 1912), (ROC)

Richard P. Howe Jr. (RPH)

INTRODUCTION

On June 26, 1833, Pres. Andrew Jackson came to Lowell, a town not yet 10 years old. Traveling by coach from Salem, he arrived late in the day to a huge welcoming ceremony. A delegation of political leaders and military units met him at the Tewksbury line. As they progressed down Church Street towards the center of town, a formation of 2,500 mill girls, all dressed in white, emerged from High Street and fell in behind the president. Turning onto Central Street and then Merrimack Street, the parade paused at Dutton Street to deposit the president and his entourage, which included future presidents Martin Van Buren and Franklin Pierce at a reviewing stand in front of the Merrimack House Hotel where a Hess gas station now stands. The president watched the entire parade pass in review. The next day he toured the Merrimack Manufacturing Company and expressed great surprise and pleasure at the favorable conditions under which the mill girls worked.

From the receipt of its town charter in 1826 up to the start of the Civil War, Lowell was one of the most important places in America. Andrew Jackson was not the only VIP to visit. Others included Charles Dickens, Davey Crockett, Abraham Lincoln, Henry Clay, and Presidents John Tyler and James Polk. They came here to see the first planned industrial city in America, the place where all the constituent parts of the Industrial Revolution—the accumulation of capital, the physical plant for large-scale manufacturing, the power needed to run the machines, and a skilled workforce valued by the employers—came together in one place for the first time.

National politicians and international celebrities were not alone in coming to Lowell. The town (it became a city in 1836) was a magnet for those with talent, energy, and drive. It was the Silicon Valley of 19th-century America. The Lowell experiment created a critical mass of people, money, and opportunity, and it gave many who started with nothing the opportunity to use their energy and imagination to make very successful lives for themselves and their families in management, banking, government, and many other fields. Such success only strengthened the bond between these individuals and the city, which is a phenomenon that continues to this day and explains, in part at least, Lowell's recent success.

The story of how this amazing city came into being is familiar. Francis Cabot Lowell was born in Newburyport just two weeks before the clashes at Lexington and Concord that began the Revolutionary War. The son of a prominent judge, Lowell set up an import/export business at an early age, made much money, and gained a powerful network of friends. Always sickly, Lowell traveled to England in 1810, hoping that an extended stay would improve his health. While there, he became fascinated by the emerging English textile industry and toured a number of mills that were springing up all over the country. Scrutinizing the machinery and business practices used by the British, Lowell imagined that he could do better. Returning to America in 1812, Lowell teamed up with Paul Moody, a skilled mechanic of moderate means from Newburyport who translated Lowell's concepts into working machinery. Lowell drew upon his network of friends and business colleagues for financial and operational support. Nathan Appleton invested money in the project and took charge of marketing the final product while Patrick Tracy Jackson became the day-to-day manager of the operation. The result was a company called the Boston Associates, which built a working textile mill in Waltham on the banks of the Charles River in 1814. The mill was a huge success, and many wealthy Bostonians clamored for opportunities to invest in this fledgling domestic textile industry.

With the option of expanding the mill in Waltham denied by the slow-flowing Charles River, Francis Cabot Lowell began to look elsewhere to grow his manufacturing enterprise. Before he could act, however, he died of consumption in 1817 at age 42. Fortunately, his vision survived and allowed his partners to move forward with plans for expansion.

Back in 1792, Dudley Tyng, William Coombs, and others had invested in a corporation that dug a transportation canal on the Merrimack River, allowing boats carrying goods from New Hampshire to circumvent the impassable Pawtucket Falls and continue on to the Atlantic Ocean at Newburyport. The end result was called the Pawtucket Canal, and for a short period of time, it was very successful. But the year after it opened, a competitor opened the Middlesex Canal, which led from the Merrimack just a mile upriver from the falls all the way to the Charles River in Boston. Since it was more lucrative to trade directly with Boston than with Newburyport, the Middlesex Canal quickly put the Pawtucket out of business.

The Pawtucket Canal lay abandoned and unused for nearly 20 years until one day in November 1821 when Patrick Tracy Jackson and his colleagues visited that stretch of the Merrimack to assess its viability as a site for a new, much larger mill complex. Satisfied that the drop in the Merrimack at this point could provide all of their hydropower needs, the Boston Associates quietly bought the rights to the Pawtucket Canal and much of the sparsely settled farmland nearby. During 1822, they widened and improved the Pawtucket Canal and constructed a mill complex alongside it that became known as the Merrimack Manufacturing Company, the first of the great mills that would operate at this site.

The city of Lowell grew rapidly. On the eve of the Civil War, the city's 52 mills were turning 800,000 pounds of cotton into 2.4 million yards of cloth each week, but changes in technology and commerce gradually weakened the city's economy. Located 29 miles from the Atlantic Ocean on a river that was only marginally navigable and 25 miles from Boston and its markets, transporting raw material to and finished products from Lowell was a challenge that increased costs and inconvenience. In the early 19th century, with no alternative to fast-running water as a power source for such a large-scale enterprise, Lowell's hydropower potential diminished the importance of these logistical challenges. Just a few decades later, the arrival of steam as a practical source of power generation changed the equation, and competing manufacturing cities arose. In 1870, Fall River overtook Lowell as the state's second-largest city. As textile production became cheaper in other places, the mills of Lowell tried to keep pace by deferring modernization of equipment and cutting wages. In this, they were assisted by an endless stream of immigrants arriving in the city from around the globe, desperate for work and willing to labor for lower wages in order to survive.

At the end of the 19th century and into the 20th century, cheaper labor, favorable laws, lower taxes, and proximity to cotton drew textile mills from Lowell to the American South. Other industries—patent medicine, shoes, munitions, printing, and electronics—came to the city, but none adequately filled the employment void left by the departed textile mills. The Depression came early to Lowell and lingered past a respite brought by full production during World War II. In the early 1970s, Lowell had the highest unemployment rate in the nation, and vacant storefronts lined the streets of downtown.

Then things changed. Today, Lowell is one of the most exciting midsized cities in post-industrial America and a world model of urban revitalization. The opening of the Lowell National Historical Park, the construction of a downtown ballpark and arena, the increasing vitality of University of Massachusetts Lowell and Middlesex Community College, and an urban planning strategy that has drawn countless creative individuals to live and work in the city all played a part, but no single event or institution is responsible for this change. Instead, this transformation flowed from the attitude of the residents of the city, both past and present.

The person who best symbolizes this attitude might be the boxer Micky Ward, whose early professional career was the subject of the Academy Award–winning film *The Fighter*. Most of Ward's fights were desperate affairs filled with staggering blows landed by both sides. Some fights Ward won; some he lost. But he never gave up. No matter how hard he was hit, he always resumed the attack. So did the city of Lowell.

After all, it was a failed business venture that helped bring Lowell to life. The Pawtucket failed as a transportation canal, but within two decades, a group of visionaries converted it to a power canal that drove the textile mills that mesmerized presidents. One hundred seventy years into the future, when Wang Laboratories went bankrupt and abandoned its six-story training center in the heart of downtown, imaginative minds at Middlesex Community College gained ownership of the building and made it the

center of the school's city campus. Sitting just across the Pawtucket Canal from the Wang Training Center was the Hilton Hotel, built in downtown on the promise of housing Wang's trainees. The computer maker's bankruptcy sentenced the hotel to decades of high vacancies and high losses for its owners. To Marty Meehan, the Lowell native and newly installed chancellor of UMass Lowell, this failed hotel was a great opportunity for the University to expand its presence in downtown, and so was born the UMass Lowell Inn and Conference Center, which houses students, hosts events, and has enlivened the center of the city. When a US district court judge was about to take over the Lowell public schools because of the failure of earlier school committees to desegregate, voters elected a new committee, and the dispute was resolved. Not only were the schools desegregated and local control maintained, but the city also jumped to the front of the line of the school building assistance program, which allowed the construction of 12 new schools and the wholesale renovation of four others, with the state paying 90 percent of the cost.

Not every failed endeavor had such beneficial outcomes. In the 1950s, many of the abandoned mills were demolished to make way for parking lots as car culture came to dominate American life. In the 1960s, a planned highway link between downtown and the new Route 495—the Lowell Connector—was only partially completed. Old, established neighborhoods like Little Canada were bulldozed in the name of Urban Renewal. Even Paul Tsongas, as a city councilor, proposed paving over the canals to create a better road network around the city. Lowell had its share of wins and losses and plenty of incompletes, but the city never stopped fighting back against the economic and social adversity that plagued American cities in the post-industrial era.

Lowell's story is of a city that will not give up. As Shakespeare wrote, "What is a city but the people?" This book tells the story of Lowell by sharing the stories of its people. They are individuals who distinguished themselves in exceptional and sometimes ordinary ways. There are newsmakers as well as quiet contributors. These are the faces of the menders and the tenders of society, the ones who inspire us, the custodians of local lore, those who had their moments, high and low, and others who went about doing good without much recognition. Constraints of space, time, and the availability of images necessitated tough choices in selecting who to include. No person or group was consciously omitted. The book seeks to be inclusive, but that is simply a reflection of the city.

Lowell's unique position in our country's narrative comes from the industrial history associated with the textile mills. The mill experience, however, does not define this complex and complicated city. People's lives beyond the shop floor and outside the business office are rich, interesting, and nearly limitless. While unique in its resilience, Lowell is also representative of the broader American experience: family, work, patriotism, religion, sports, politics, and culture. All are aspects of life that transcend occupation and profession and all are present in Lowell.

CHAPTER ONE

Mills

On a snowy November day in 1821, Nathan Appleton, Patrick Tracy Jackson, Paul Moody, Kirk Boott, and his older brother John Wright Boott, gathered near the Merrimack River to view together for the first time their purchase of land, locks, canals, and water rights of their planned water-powered industrial city that would be called Lowell. On February 6, 1822, these gentlemen incorporated the Merrimack Manufacturing Company, with Warren Dutton, a brother-in-law of Francis Cabot Lowell, as president. The Merrimack Manufacturing Company started work on April 1, 1822, with a dam across the Merrimack River at the Pawtucket Falls and 500 newly hired Irish laborers to widen and deepen the Pawtucket Canal. To buy all the machine patents owned by the Boston Manufacturing Company at Waltham and to acquire the services of Paul Moody, $75,000 was spent. On September 1, 1823, the Merrimack Manufacturing Company began operations. It would soon consist of five mills, a print works, 155 boarding houses, 42,600 spindles, and 1,300 looms.

In 1824, the Merrimack Company transferred the machinery patents from Waltham to its own machine shop in Lowell under the direction of Paul Moody. The Lowell Machine Shop built the machinery for the other Lowell mills as well as selling it further afield. The Hamilton Manufacturing Company, with John Lowell Jr., son of Francis Cabot Lowell as a major shareholder, was formed in 1825, followed by the Appleton Company (1828), Lowell Manufacturing Company (1828), Middlesex Woolen Company (1830), Suffolk and Tremont Mills (1831), Lawrence Mills (1831), Lowell Bleachery (1832), the great Boott Cotton Mills (1835) and the Massachusetts Mills (1839).

The golden age of Lowell's textile mills was short lived, however, as changes in technology, transportation, and labor made it cheaper to manufacture cloth elsewhere. The textile companies decamped, leaving vacant mill buildings, many of which were demolished in the name of Urban Renewal. Some mill buildings survived and became part of Lowell's future, drawing to the city a National Historic Park and cutting-edge companies engaged in the global economy.

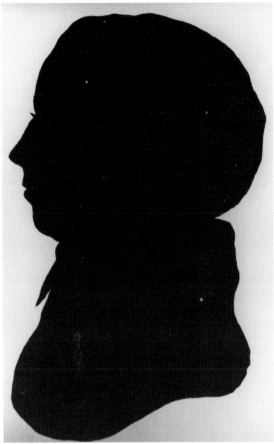

Francis Cabot Lowell

Lowell (1775–1817) graduated from Harvard College then set up as a merchant. He imported handspun and hand-woven cotton textiles from India and silks from China. His India Wharf was the headquarters of trade with the Orient. After returning from a trip to Great Britain, he was determined to manufacture textiles at home using waterpower. This silhouette is the only known likeness of Lowell. (Courtesy of the Library of Congress.)

Boston Manufacturing Company

In 1814, Francis Cabot Lowell launched the Boston Manufacturing Company, powered by the flow of the Charles River at Waltham. The mill employed the first power loom in America. Raw cotton was spun into thread and woven into cloth, all under one roof. Lowell built boardinghouses to accommodate the young women who came to work in his factory. (Courtesy of Waltham Room, Waltham Public Library.)

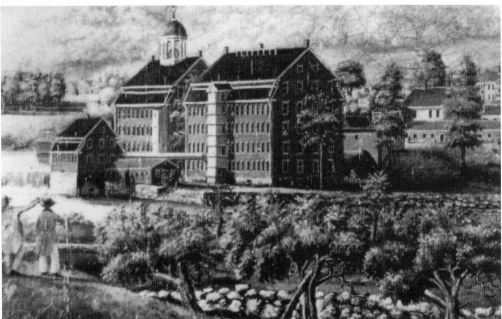

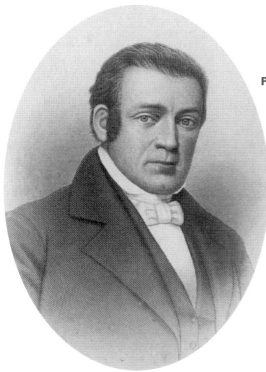

Paul Moody
Described as a mechanical genius, Newburyport native Paul Moody (1779–1831) teamed with Francis Cabot Lowell to build the power loom for the Waltham mill based on what Lowell had seen in Great Britain. At Waltham, Moody built and ran the machinery for the Boston Manufacturing Company. In 1825, he moved to Lowell to run the Lowell Machine Shop. (Courtesy of CH.)

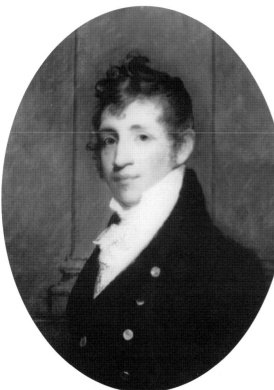

Nathan Appleton
Born in New Ipswitch, New Hampshire, Nathan Appleton (1781–1861) made his fortune as a young man in partnership with his brother Samuel. In 1811, while in Edinburgh, Scotland, Appleton met Francis Cabot Lowell and became an early investor in the Waltham Mill. Along with Paul Moody and Patrick Tracy Jackson, Appleton was one of the founders of the city of Lowell. His daughter Fannie married the poet Henry Wadsworth Longfellow. (Courtesy of Longfellow National Historic Site, National Park Service.)

Patrick Tracy Jackson

Patrick Tracy Jackson (1780–1847), born in Newburyport, was a brother-in-law of Francis Cabot Lowell. In 1813, he agreed to move to Waltham to set up and run the Boston Manufacturing Company where he developed the Waltham System of textile production and marketing. He remained there until 1825, when he moved to Lowell. Jackson was the driving force behind the Boston and Lowell Railroad, one of the first railroads in America. (Courtesy of IHL.)

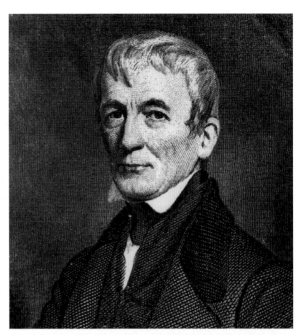

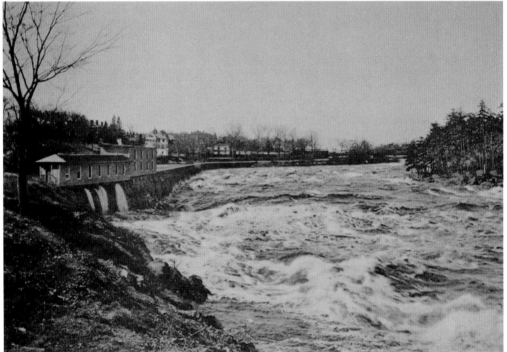

Pawtucket Falls

The Pawtucket Falls on the Merrimack River had been a gathering place for the region's indigenous people long before the English arrived. In 1647, John Elliott visited the falls to introduce the residents to Christianity. Beginning at the falls, the Merrimack drops 32 feet in one mile, posing a significant obstacle to navigation. (Courtesy of Library of Congress.)

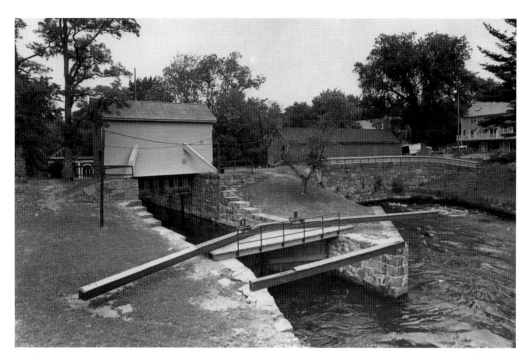

Pawtucket Canal

In 1792, a group led by Dudley Tyng incorporated as The Proprietors of the Locks and Canals on Merrimack River to build a transportation canal that would bypass the Pawtucket Falls. Initially successful, the Pawtucket Canal was quickly put out of business by the competing Middlesex Canal. In 1822, the Boston Associates purchased the dormant canal and repurposed it for power generation for the new textile mills. (Courtesy of Kevin Harkins.)

James Sullivan

James Sullivan (1744–1808) was the driving force behind the construction of the Middlesex Canal connecting the Merrimack River, one mile before the Pawtucket Falls, with the Port of Boston. Sullivan served as attorney general and later governor of the Commonwealth of Massachusetts. The Middlesex Canal Company was incorporated in 1793 with the canal completed in 1804 at a cost of $700,000. (Courtesy of Library of Congress.)

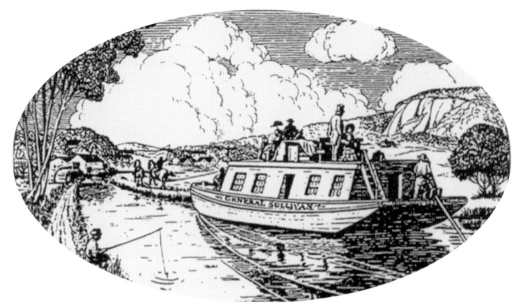

Middlesex Canal Boat
Twenty-seven miles long, 24 feet wide, and four feet deep with 20 locks, the Middlesex Canal allowed lumber, farm produce, and passengers from New Hampshire to reach Boston in just 24 hours. Its success put the Pawtucket Canal out of business and diminished the importance of Newburyport. The illustration shows the canal boat *General Sullivan* being towed along the canal by horses. (Drawing by Louis Roscoe Linscott, Middlesex Canal Association, Billerica, Massachusetts.)

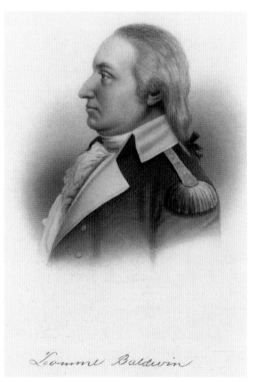

Loammi Baldwin
Born in Woburn, Loammi Baldwin (1744–1808) was with George Washington at the crossing of the Delaware and the battle of Trenton. Baldwin, who became known as the father of American civil engineering, surveyed and supervised the construction of the Middlesex Canal. His name is associated with the Baldwin apple, first grown on his farm. (Courtesy of IHL.)

Kirk Boott

Born in Boston but sent to England to attend Rugby School, Kirk Boott (1791–1837) saw action in the Peninsular Wars against Napoleon as a British army officer. He returned to Boston in 1817, befriended Patrick Tracy Jackson, and was appointed agent to the Boston Manufacturing Company. He moved to Lowell in 1822 as first agent and treasurer of the Merrimack Manufacturing Company. (Courtesy of CH.)

Lowell City Seal

With multiple mill buildings, a train passing a pile of cotton bales, and a boat being towed along a Middlesex Canal viaduct, the seal of the City of Lowell is like a snapshot of the early city. The city motto, "Art is the handmaid of human good," refers to the mechanical arts practiced by Paul Moody and others, but it applies just as well to the city's creative economy in the 21st century. (Courtesy of RPH.)

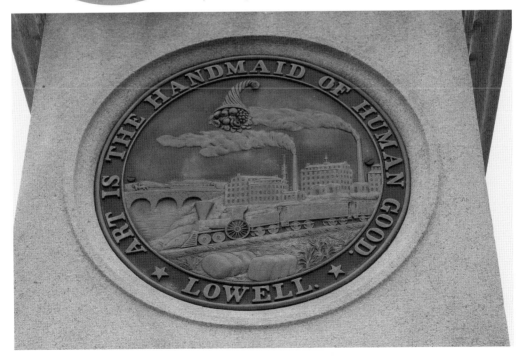

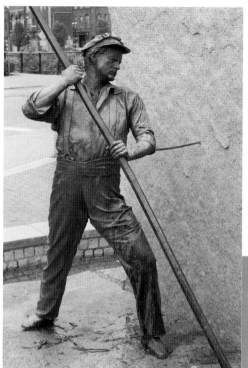

Hugh Cummiskey, The Worker
Located across from the National Park Visitor Center and designed by Elliott and Ivan Schwartz in 1985, *The Worker* depicts an Irish laborer widening one of Lowell's canals. The first such laborers were led to Lowell from Charlestown in 1822 by Hugh Cummiskey, who became a leader of the Irish community in Lowell until his death in 1871. No image of Cummiskey is known to exist. (Courtesy of RPH.)

St. Patrick's Church
The Irish came to Lowell in ever increasing numbers, mostly as laborers. Unlike the Yankee mill girls who were housed in quarters owned by the corporations, the Irish settled in an undeveloped area about an acre in size. The Acre, as it became known, was the site of one of the first Roman Catholic churches north of Boston, St. Patrick's, which was built of wood in 1831 and was replaced by a stone structure in 1853. (Courtesy of David McKean.)

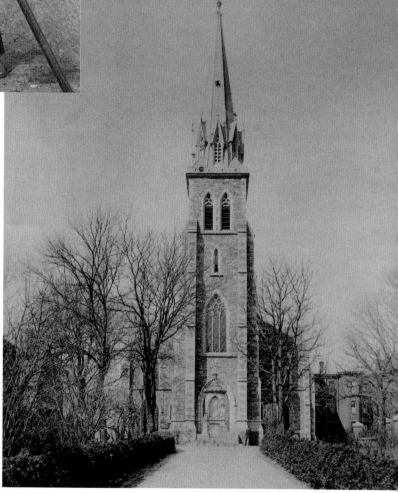

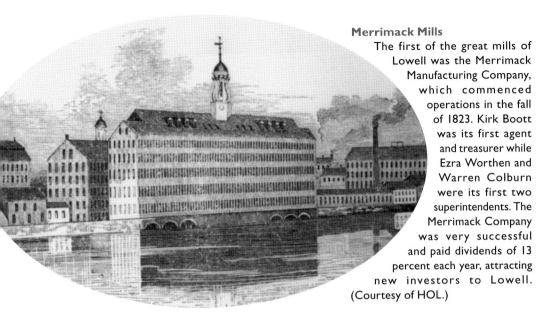

Merrimack Mills
The first of the great mills of Lowell was the Merrimack Manufacturing Company, which commenced operations in the fall of 1823. Kirk Boott was its first agent and treasurer while Ezra Worthen and Warren Colburn were its first two superintendents. The Merrimack Company was very successful and paid dividends of 13 percent each year, attracting new investors to Lowell. (Courtesy of HOL.)

Lucy Larcom
Born in Beverly, Massachusetts, Lucy Larcom (1824–1893) came to Lowell at age 11 when her widowed mother became a boardinghouse keeper. Forced by economic necessity to forego school and work in the mills, Lucy still found time to write stories and poetry about her experience. She moved from Lowell at age 21 and became a teacher and writer. (Courtesy of LL.)

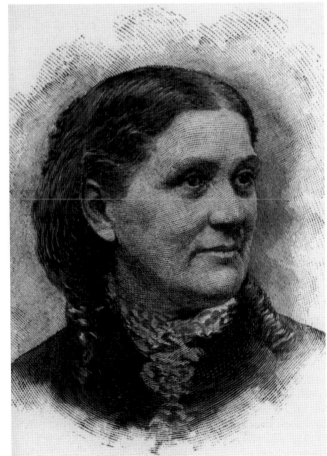

Mill Girl
Most of the workers in Lowell were young women lured to the mills from New England farms by the offer of cash wages, board, and comfortable lodging. Living four to a room, they worked long hours and generally remained two or three years before marrying or returning to the farm. In this photograph, a ranger of the Lowell National Historical Park explains the life of a mill girl while wearing period costume. (Courtesy of RPH.)

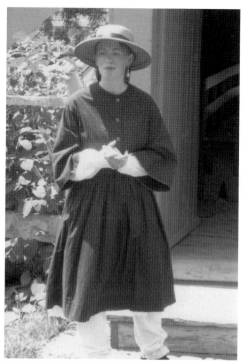

Dutton Street Boardinghouse
Built in 1823 on the street named for Warren Dutton, brother-in-law of Francis Cabot Lowell, these boardinghouses were home to thousands of farm girls from across New England who came to work in Lowell's mills. The boardinghouses provided structured living under the watchful eye of boardinghouse keepers as well as intellectual stimulation and companionship. Most were demolished in the 1960s. (Courtesy of Library of Congress.)

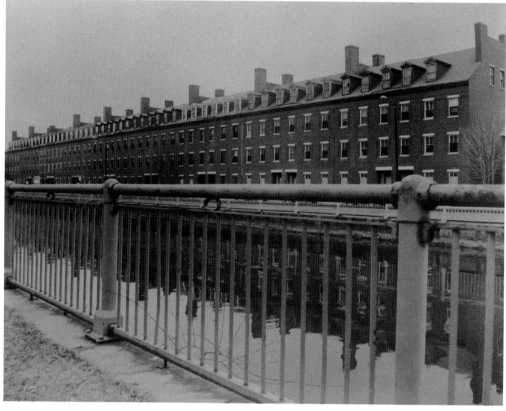

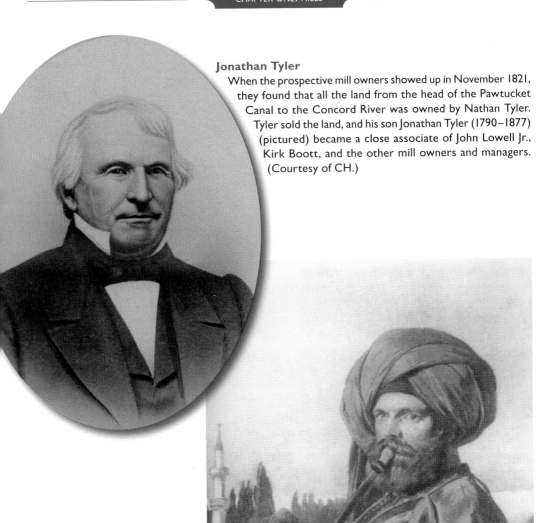

Jonathan Tyler
When the prospective mill owners showed up in November 1821, they found that all the land from the head of the Pawtucket Canal to the Concord River was owned by Nathan Tyler. Tyler sold the land, and his son Jonathan Tyler (1790–1877) (pictured) became a close associate of John Lowell Jr., Kirk Boott, and the other mill owners and managers. (Courtesy of CH.)

John Lowell Jr.
The eldest child of Francis Cabot Lowell, John Lowell Jr. (1799–1836) moved to Lowell in 1825 and became actively involved in textile mill operations. When his wife and daughters died of scarlet fever, he liquidated his holdings and retraced Marco Polo's overland route to China, accompanied by Swiss artist Charles Gabriel Gleyre who produced this painting of Lowell in Cairo. John Lowell Jr. died of disease in Bombay in 1836. (Courtesy of HLI.)

William Appleton
William Appleton (1786–1862) worked in a store in New Hampshire before coming to Boston to start a career as a merchant. On the advice of his first cousin, Nathan Appleton, he entered "into the Manufactory business . . . and made considerable money" as one of the first investors in the Hamilton Mills. In 1829, his estimated worth was $200,000, growing three years later to $330,000. (Courtesy of WA.)

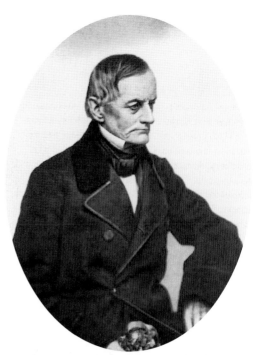

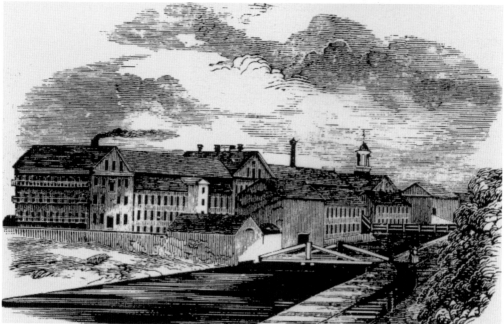

Appleton Mills
The incorporation of the Appleton Manufacturing Company in 1828 heralded the entry of Boston's wealthy merchants and directors of banking and insurance companies into domestic textile manufacture. The mill was named for Nathan Appleton and his brother Samuel with William Appleton serving as treasurer. By 1845, the Appleton Mills had 400 looms, 11,776 spindles, and 400 employees. It was the first of the Lowell mills to use turbine waterpower. (Courtesy of IHL.)

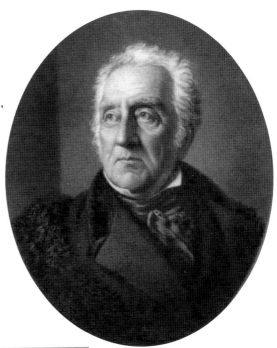

Thomas Handasyd Perkins

One of Boston's most successful merchants, Thomas Handasyd Perkins (1764–1854) began as a slave trader out of Haiti and then shipped Turkish opium to China for fine silks and crockery. A model of respectability at home, he supported the Boston Athenaeum and a school for the blind, still known as the Perkins School. Seeing the success of the textile mills, he invested in the Appleton and other companies in Lowell. (Courtesy of THP.)

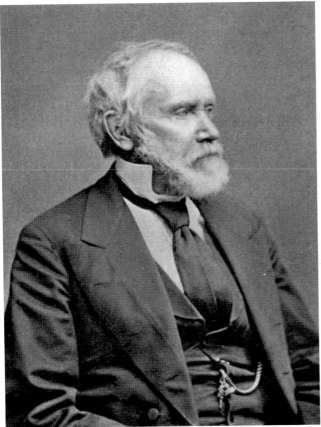

John Amory Lowell

The nephew and son-in-law of Francis Cabot Lowell, John Amory Lowell (1798–1881) was the most prominent of the second generation of the Lowell family in cotton textile manufacturing. In 1835, he joined Abbott Lawrence and Nathan Appleton as the primary shareholders of the Boott Cotton Mill and served as the treasurer of that facility. He was also the first trustee of the Lowell Institute, which brought esteemed academics to lecture in Boston. (Courtesy of IHL.)

Amos Lawrence and Abbott Lawrence

Although their fortune was derived from the sale of imported goods, when Groton, Massachusetts natives Amos (1786–1852) (right) and Abbott Lawrence (below) discovered the quality of the cloth made by the Merrimack Manufacturing Company, they became sales agents of locally produced cotton and woolen goods. Convinced by Nathan Appleton to invest, the Lawrence brothers became major stockholders in the Tremont and Suffolk Mills and established their own Lawrence Mills, which by 1900 was the world's largest producer of hosiery. Abbott Lawrence (1792–1855) entered politics to advocate tariffs against imports and to champion "the true interests of our own people." He served in the US House of Representatives and also as American ambassador to Great Britain. On April 17, 1845, Abbott Lawrence established the Essex Company to build a new industrial city farther along the Merrimack River, named Lawrence in his honor. (Both courtesy of DAL.)

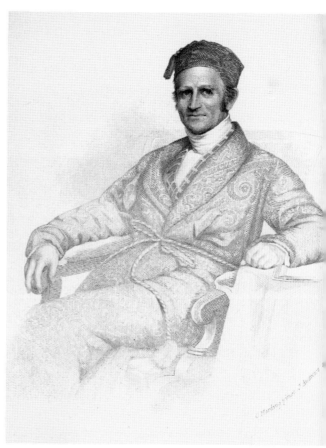

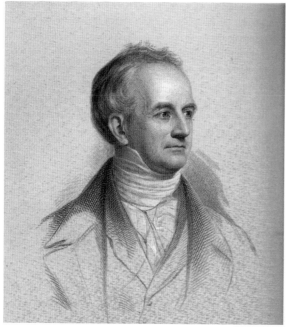

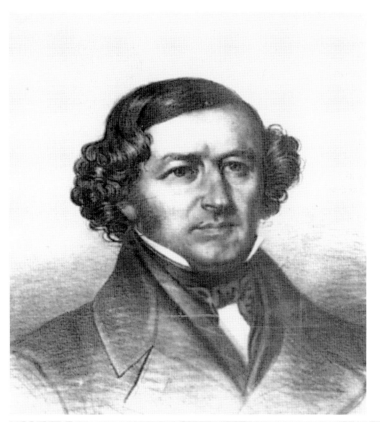

George Washington Whistler
After Paul Moody died in 1831, George Washington Whistler, a West Point–trained engineer and father of the famous painter, replaced Moody as director of the Lowell Machine Shop, which had just begun building railroad locomotives. During his three-year tenure in Lowell, 32 locomotives were built. Whistler resigned in 1837 and went to Russia to build the Moscow to St. Petersburg railway. He died there of cholera in 1849. (Courtesy of IHL.)

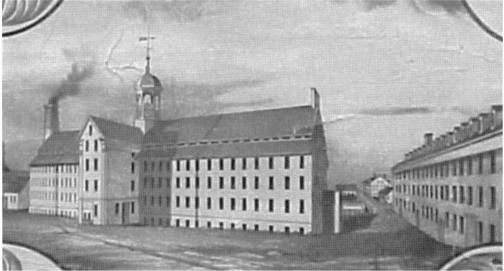

Lowell Machine Shop
The machinery for Lowell's first mill was built in Waltham but the Merrimack Manufacturing Company soon established its own machine shop to construct machinery for use in the city's expanding mills. Incorporated in 1845 as a separate company, the Lowell Machine Shop was soon producing cotton machinery, water turbines, and even locomotives for companies across America. (Courtesy of LMS.)

Mills on the Merrimack
By 1860, Lowell was the second largest city in Massachusetts with 36,000 residents, with nearly 14,000 employed in the city's 52 textile mills. Each week, those mills turned 800,000 pounds of cotton into 2.4 million yards of cloth. Railroads became increasingly important to transport cotton to the city and finished goods from the city to markets. (Courtesy of ROC.)

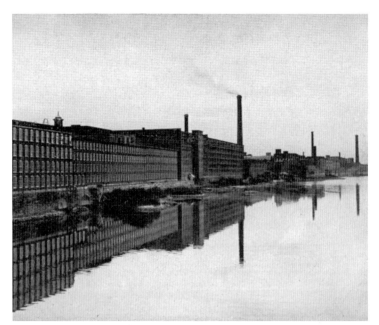

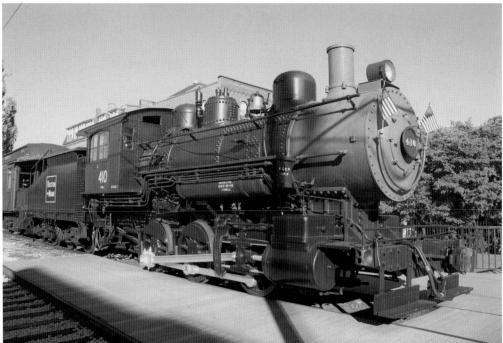

Lowell Locomotive
The Lowell Machine Shop was one of the first in America to build steam locomotives. One of the first was called *Patrick* in honor of Patrick Tracy Jackson. From 1835 to the 1860s, the Lowell Machine Shop built 100 steam locomotives. This locomotive, no. 410, was built in Manchester in 1911 and operated on the Boston and Maine Railroad. It is part of a railway exhibit in the Lowell National Historical Park. (Courtesy of RPH.)

Boston and Lowell Railroad
Lowell's rapid growth taxed the available transportation systems. Stagecoaches and oxcarts were slowed by snow and mud, and the Middlesex Canal froze over in the winter, making it impassible. By 1830, the directors of the Locks & Canals were eager to establish a steam-powered railroad between Boston and Lowell to handle the 24 tons of freight and 100 passengers that passed between the two cities each day. (Courtesy of LMS.)

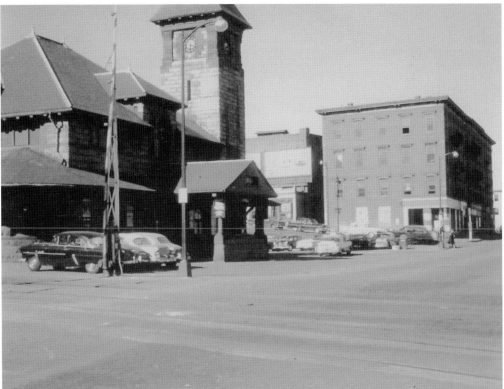

Lowell Depot
Steam railroads had their beginning in Massachusetts with the Boston and Lowell Railroad, chartered on June 5, 1830. When service began in 1835, trains left Lowell at 6:00 a.m. and 2:30 p.m. and Boston at 9:00 a.m. and 5:30 p.m. In the 1800s, Lowell had a number of train stations around the downtown, but during the first half of the 20th century, the main depot was this one on Middlesex Street. (Courtesy of Anne Marie Page.)

James Bicheno Francis

Succeeding George Whistler as chief engineer in 1837 was his 22-year-old, English-born assistant, James B. Francis (1815–1892). For the next 47 years, Francis redesigned the canals, invented a water turbine that is still used around the world today, and created a modern sprinkler system in the mills. Perhaps his greatest achievement was the publication in 1855 of his *Lowell Hydraulic Experiments*, which documented two decades worth of his analysis of waterpower in Lowell. This distinctly American work replaced the European texts previously in use and was employed by every industry in America that used waterpower. Francis also did much to promote engineering, teaching his techniques to professional colleagues and serving as the president of the American Society of Civil Engineers. The photograph below is of the society's 1878 annual meeting in Lowell. (Left, courtesy of ORA; below, courtesy of Library of Congress.)

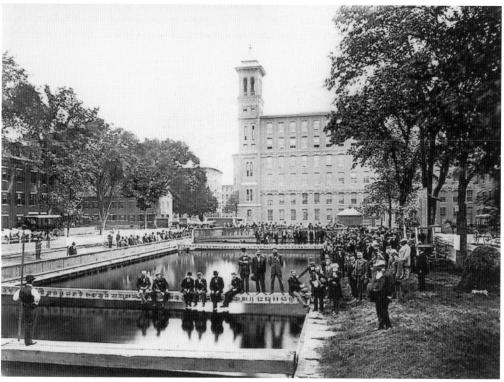

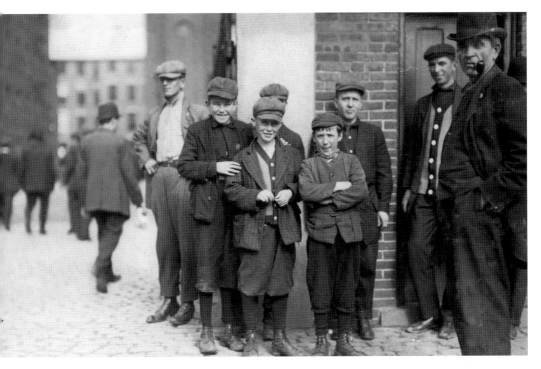

Child Mill Workers
Employing children as a cheap form of labor became common practice in New England after 1840, but Massachusetts was in the forefront of keeping children in school and out of factories. Still, a number of children in Lowell continued to work. This 1911 photograph by Lewis Hine shows Robert Magee (smallest), Michael Keefe (next in size), and Cornelius Hurley, all employees of the Merrimack Mill. (Courtesy of Library of Congress.)

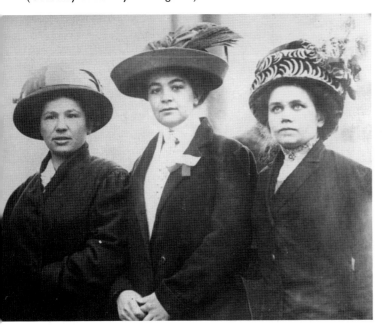

Portuguese workers
Portuguese from the Azores had long worked on whaling ships and settled in New Bedford. Starting around 1890, Portuguese started coming to Lowell to find work in the mills. They established a Catholic church on Central Street near the corner of Floyd Street. By 1916, Portuguese settlers in Lowell numbered over 3,000. (Courtesy of Library of Congress.)

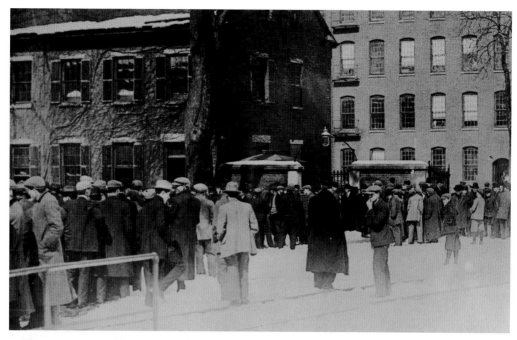

Strikers at Merrimack Mill
Recurring strikes by workers began within a few decades of the opening of the mills but intensified in the early 20th century, when pressure on the companies to keep costs low collided with worker demands for better conditions and higher wages. While some of Lowell's newer immigrant groups successfully organized along ethnic lines, support for unions in Lowell was tenuous even in the working class. (Courtesy of Library of Congress.)

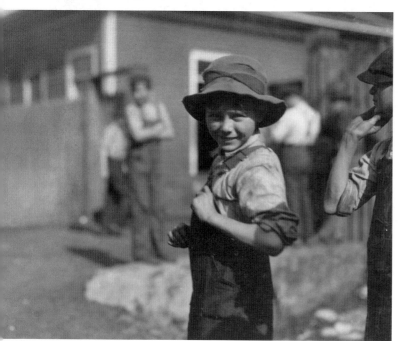

Mills Move South
This 1913 photograph by Lewis Hine shows "Charlie Foster, age 10, employee of Merrimack Mills, Huntsville, Alabama." Stricter laws, the power of trade unions, higher wages, and a shorter workday made the northern mills more expensive than mills in the South. The Merrimack Manufacturing, the Massachusetts Mills, and many others opened branches in the South, with many abandoning their northern facilities entirely. (Courtesy of Library of Congress.)

Frederick A. Flather
When Frederick Flather (1867–1967) married Alice Rogers, he joined the family that had founded the Boott Mills in 1843. Frederick worked elsewhere until 1905, when he was made manager of the Boott. By 1914, he and his sons ran the Boott Mills, but Southern competition, rising labor and transportation costs, and a failure to invest in modern machinery forced the closure of the Boott in 1956. (Courtesy of MC.)

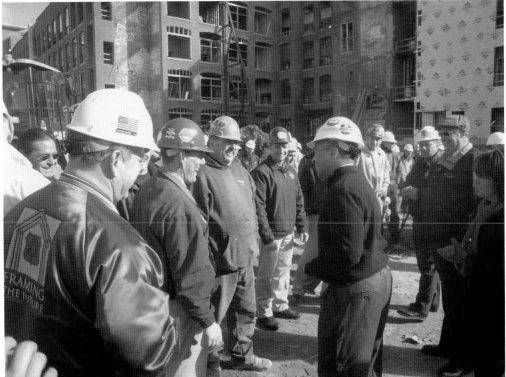

Appleton Mills Redevelopment
Long abandoned, the Hamilton and Appleton Mills have become the centerpiece of the city of Lowell's most ambitious redevelopment project in decades. The Hamilton Canal District seeks to reinvent 15 acres of vacant and underutilized land as a vibrant mixed-use neighborhood. This photograph shows Massachusetts governor Deval Patrick speaking with construction workers during a November 2010 visit to the site. (Courtesy of RPH.)

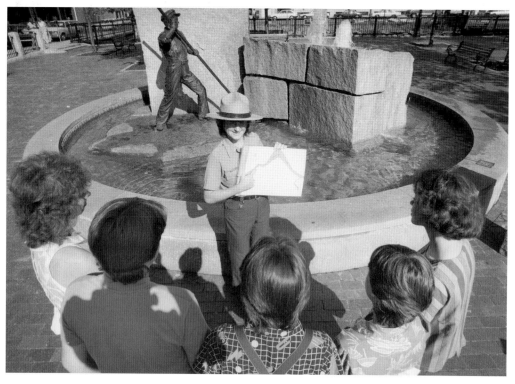

National Park Tour

Rangers of the National Park Service like Becky Warren are much in evidence in downtown Lowell, leading visitors on tours of the historic mill city as in the photograph above. The park is not segregated from the downtown; it is the downtown, with key National Park facilities interspersed with newly renovated 19th century buildings. The centerpiece is the Boott Cotton Mill Museum, shown in the photograph below, in which 88 working looms recreate not only the sights but also the sound and feel of life in the mills. Shortly after the 1992 opening of the museum, the *New York Times* wrote "Restoring the old canals and the long-shuttered mills has given new hope and dignity to a Lowell now entering the post-industrial revolution." (Above, courtesy of Kevin Harkins; below, courtesy of RPH.)

CHAPTER TWO

Business

Lowell owed its existence to textile mills, but the city's dominance in that field began to fade as early as the Civil War. As the mills regressed, other businesses tried to fill the void to varying degrees of success. Life in 19th century America was precarious, with illnesses eradicated or easily managed today often proving fatal back then. With society struggling to find effective treatments, talented young men working in pharmacies concocted remedies of all types and soon spun off medicine-making companies that sold to a worldwide audience. With many medicines nearly identical, advertising became a precondition to success. Much of the promotional literature was produced in-house, which created a pool of printers who often opened their own businesses in the city. To fill mill buildings left vacant by departed textile companies, heavy industries such as shoe production and munitions manufacturing became significant local employers. Technology was also an important field. After a demonstration in Lowell of the still-novel telephone by Alexander Graham Bell, many in the city invested, and Lowell became an early adopter of this new technology. A local physician, Moses Greeley Parker, is said to have invented the telephone number in 1879. A measles epidemic was ravaging the city, and Parker worried that the four telephone operators would become sick and miss work. Since the identity of the owners of the various phone lines was known only to these operators, their absence would shut down the system. Parker proposed numbering the lines to ease the training of replacements. A system of four-digit numbers was put in use with so much success that it was adopted around the world. Telephones were not the only technology business in the city. In the 1970s, computer-maker Wang Laboratories located here and was one of the region's largest employers until the company's demise in the early 1990s. Despite the diversity of services and products offered by businesses in Lowell, one thing that united all was community involvement. The philanthropic impulse in owners and employees has always been strong in good economic times and in bad.

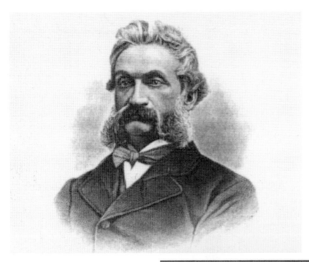

James Cook Ayer

Born in Groton, Connecticut, James C. Ayer (1819–1878) came to Lowell at age 13 to work in an apothecary. Opening his own drugstore in 1841, Ayer began concocting his own medicines and through the shrewd use of advertising built the most successful patent medicine company in America. The $20 million fortune derived from patent medicine sales financed Ayer's diversification into mill ownership and his many acts of civic generosity. (Courtesy of IHL.)

Ayer's Sarsaparilla

Ayer's Sarsaparilla was the company's most successful product. Introduced in 1859, Sarsaparilla was recommended for a range of ailments, including jaundice, dyspepsia, pimples, boils, ringworm, and "female weaknesses." Beginning in 1860, Ayer advertised his Sarsaparilla with a letter signed by more than 40 mayors from cities such as Boston, New York, Montreal, Chicago, Lowell, and many others. (Courtesy of Chaim Rosenberg.)

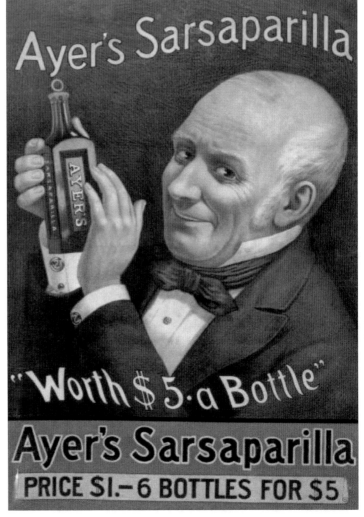

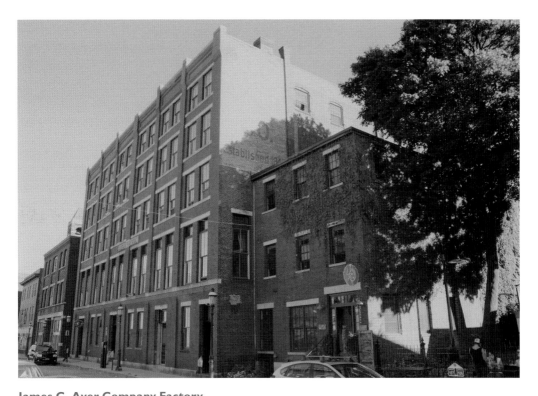

James C. Ayer Company Factory

At its factory at 90 Middle Street in downtown Lowell, the James C. Ayer Company employed 300 workers who used 325,000 pounds of drugs, 220,000 gallons of spirits, and 400,000 pounds of sugar to produce one year's worth of medicine. Its inventory of bottles alone was worth $1.5 million. The Ayer Company issued multicolor trade cards and almanacs to advertise its medicines, which were sold the world over. (Courtesy of RPH.)

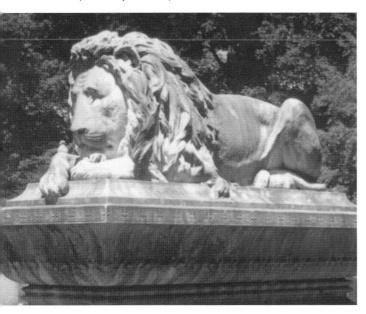

Ayer Lion at Lowell Cemetery

After the Civil War, James C. Ayer became more philanthropic, donating a magnificent statue (*Winged Victory*) to Lowell and money to a new town (Ayer, Massachusetts) but his defeat in his first-ever run for Congress in 1874 shattered his health. When he died in 1878, his family commissioned Irish-born artist Bruce Price-Joy to sculpt this 25-ton marble lion to mark Ayer's grave in Lowell Cemetery. (Courtesy of RPH.)

Frederick Fanning Ayer

Born in Ledyard, Connecticut, Frederick Ayer (1822–1913) moved to Lowell to join his brother's already booming patent medicine business. Seeking to diversify, the brothers bought the controlling shares of the Tremont and Suffolk Mills. After James's death, Frederick purchased the Washington Mills in Lawrence and established the American Woolen Company, which eventually operated woolen mills throughout New England. (Courtesy of MBA.)

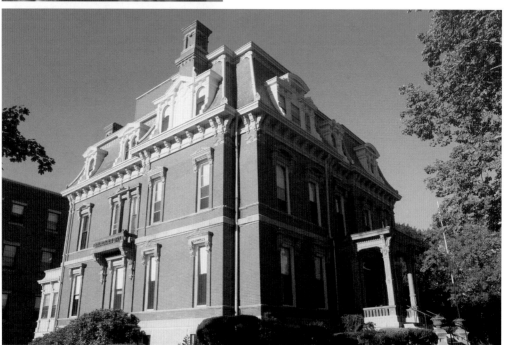

Frederick Ayer Mansion

In 1876, Frederick Ayer built a grand 67-room mansion at the corner of Pawtucket and School Streets. The mansion became the Franco-American Orphanage in 1899 when Ayer moved to Boston, where his new home at 395 Commonwealth Avenue was decorated by Louis Comfort Tiffany. In 1910, Ayer's daughter Beatrice married a young cavalry officer named George S. Patton who attained three stars and lasting fame in World War II. (Courtesy of RPH.)

Charles Ira Hood

As a boy, Charles Ira Hood (1845–1920) worked in his father's Chelsea, Vermont, apothecary before opening his own shop in Lowell at age 25. Hood achieved tremendous success with the sale of his sarsaparilla, which was 18 percent alcohol. Other successful products were Hood's tooth powder, vegetable pills, oil ointment, medicated soap, and lotion. He died in 1922 at age 77; his company's end soon followed. (Courtesy of MOT.)

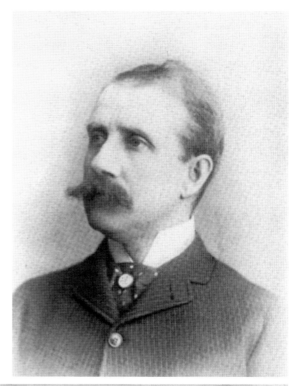

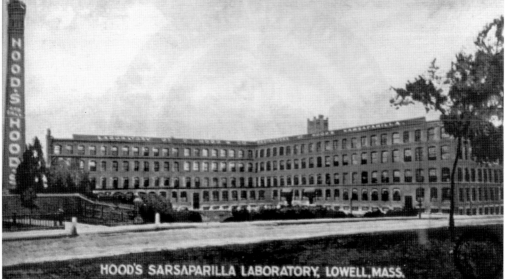

HOOD'S SARSAPARILLA LABORATORY, LOWELL, MASS.

C.I. Hood Company Factory

Business was so brisk that Charles Hood needed a larger space. In 1882, he built the four-story Hood's Laboratories on Thorndike Street, close to the Boston & Lowell Railroad depot. Advertising was critical to the patent medicine business, so Hood's building included a printing plant that produced 70 million promotional pieces in 1879 alone. Hood was the largest single user of the US mail in Lowell. (Courtesy of Chaim Rosenberg.)

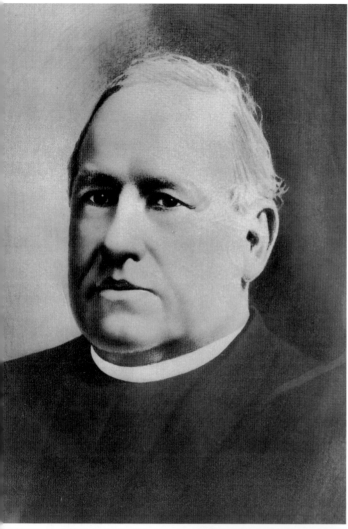

Fr. John O'Brien

When George Carleton and Charles Hovey concocted a cough medicine from cod liver oil and balsam of tolu, one of their best customers was Fr. John O'Brien (1800–1874), who was soon recommending the product to his parishioners at St. Patrick's Church. When local sales soared, Carleton and Hovey closed their drugstore, built a manufacturing plant on Market Street, and launched a nationwide advertising campaign for Father John's Medicine. (Courtesy of Dave McKean.)

Father John's Medicine Bottle

Like other producers of patent medicine, Carleton and Hovey used distinctive bottles and extravagant claims to differentiate their product. Father John's Medicine claimed to be "without equal" as a body builder and was advertised as a cure for consumption, coughs, colds, whooping cough, bronchitis, thin blood, hoarseness, and a weak voice, but a 1915 analysis by the National Association of Retail Druggists concluded such claims were unfounded and imposed a hefty fine. (Courtesy of Chaim Rosenberg.)

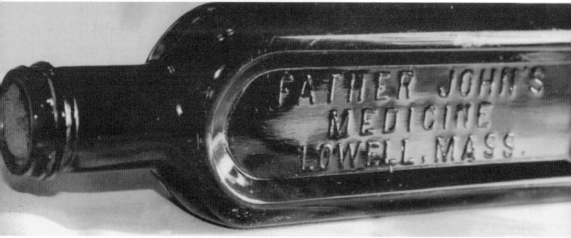

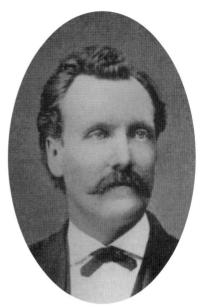

Augustin Thompson
After serving in the Union Army and attending medical school, Augustin Thompson (1835–1903) opened his medical practice in Lowell. Like other physicians, he mixed his own medicines, including one introduced to him by a fictional character named Lieutenant Moxie. The medicine was so popular that Thompson gave up his practice and devoted all his effort to manufacturing and selling Moxie Nerve Food, which became Moxie, a soft drink still sold today. (Courtesy of IHL.)

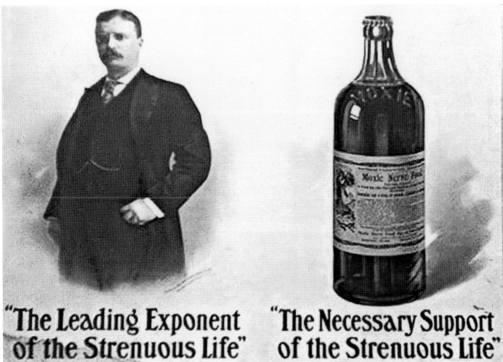

"The Leading Exponent of the Strenuous Life" "The Necessary Support of the Strenuous Life"

Moxie Advertisement
Moxie Nerve Food, a concoction of gentian root, sassafras, wintergreen, caramel, sugar, and water, was recommended to help the appetite, calm the nerves, and restore sleep. The company used the image of Pres. Theodore Roosevelt, an enthusiastic exponent of the strenuous life, in its advertising. After taking the oath as president, Calvin Coolidge exclaimed, "Guess we better have a drink!" before toasting the occasion with a Moxie. (Courtesy of Chaim Rosenberg.)

Eli Hoyt

At age 13, Eli Hoyt (1838–1887) began working at the apothecary of E.A. Staniels, where he produced and sold Hoyt's Cologne, which his close friend and eventual partner Freeman Shedd renamed Hoyt's German Cologne to create an exotic aura. The product was so successful that Hoyt and Shedd shifted to fulltime production and became quite wealthy. Hoyt died from tuberculosis at age 48. (Courtesy of IHL.)

Freeman Shedd

A Civil War veteran with a genius for marketing, Freeman Shedd (1844–1913) helped make Hoyt's German Cologne an internationally known product. When colored trade cards came into wide use, he dipped some in cologne and invented the scented advertising card. After the death of Eli Hoyt, Shedd endowed a tuberculosis wing at Lowell General Hospital and bequeathed 50 acres to the City of Lowell for public recreation. (Courtesy of Richard Leach.)

Sullivan Brothers Printing

Introduced to printing as a young pressman at the *Lowell Sun*, Joseph Sullivan (1895–1972) joined his brothers to form their own printing company in 1916. By the 1930s, Sullivan Brothers Printing, then owned solely by Joe, had become the largest producer of sports printing in America, with customers ranging from racetracks to Notre Dame football. Catholic churches and colleges were also substantial customers and he was one of their greatest benefactors. In the early 1960s, Joe convinced nine others to contribute $25,000 each to become co-owners of the Boston Patriots, with his nephew Billy serving as general manager. The printing company was subsequently operated by Joseph's son Joseph Jr. and granddaughter Ellen, who is in the photograph below. (Left, courtesy of Helen McNamee; below, courtesy of Kevin Harkins.)

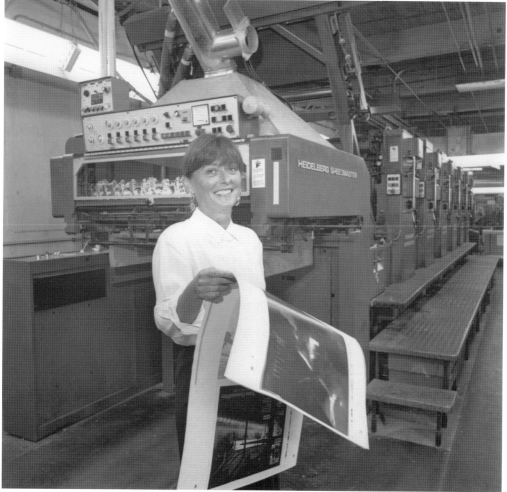

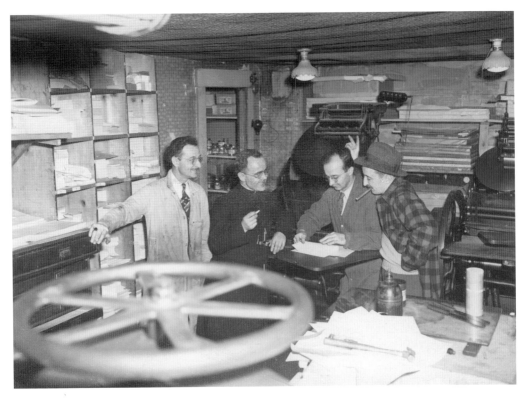

Eno Printing
Eno Printing was a small print shop at 31–33 Race Street in the heart of Little Canada. In this 1946 photograph, from left to right, Leandre Eno, Father L'Hermitte, Camille Eno, and Arthur Eno examine religious cards printed for Father L'Hermitte and Father Deberge, both natives of Belgium, for their overseas missionary work. Both Leandre (US Navy) and Arthur (US Army) had just returned from military service in World War II. (Courtesy of Leon Eno.)

National Biscuit Company
In the early 20th century, residents bought groceries at hundreds of neighborhood markets. Salesmen for food manufacturers regularly called on such stores and orders were fulfilled by deliverymen such as James Smith (pictured) who worked for the National Biscuit Company, today known as Nabisco. A century later, fading advertising murals for Nabisco's UNEEDA biscuit and its innovative "In-Er Seal" wax paper packaging still appear on Lowell buildings. (Courtesy of Mary Howe.)

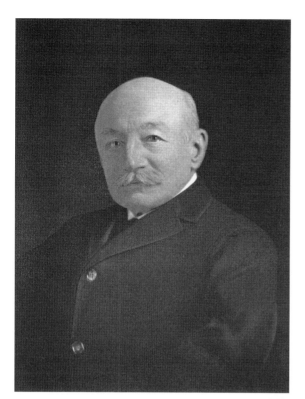

Paul Butler
After graduating from Harvard in 1875, Paul Butler worked at and eventually owned United States Cartridge Company, which was founded by his father, Benjamin Butler. Paul became a world-famous inventor of machinery for making ammunition and made US Cartridge one of America's largest munitions manufacturers (despite a tragic explosion in 1903 that killed dozens). After Paul's death in 1918, National Lead Company purchased the Lowell business and moved it to New Haven. (Courtesy of MC.)

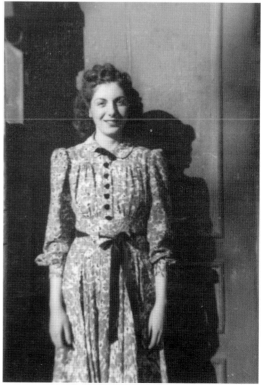

Rose Narzakian
The daughter of Armenian immigrants, Rose Narzakian (1921–present) worked at Raytheon's South Lowell plant assembling missiles, eventually becoming a "group leader" and working for the company for more than 20 years. Raytheon was a large employer in Lowell, but the peace dividend from the end of the Cold War led to the closure of the Lowell facility. (Courtesy of Rose Narzakian.)

Nicholas and Demetra "Julia" Tsapatsaris

The story of Nicholas and Demetra Tsapatsaris is in many ways representative of the immigrant experience in Lowell. Born in Greece in 1897, Nicholas arrived in Lowell in 1912, finding work in the shoe industry, which was a significant employer in the city. Demetra, who became known as Julia in Lowell, followed the same path from Greece to Lowell where she met and married Nicholas who became a US citizen in 1929, with John Ekononamakas and Drakoulis Behrakis attesting to his good character. In 1919, Nicholas purchased a lot on Mammoth Road in a rural part of Lowell known as Pawtucketville. He built two houses; a two-family, which his family shared with a French-Canadian toolmaker named John Laforest and his family, and another two-family, half of which was rented to the Tavoularis family. (One of the Tavoularis children, Dean, won the Best Art Direction Academy Award in 1974 for *Godfather Part II*). With most of Lowell's immigrants coming from farming communities,

anyone with a plot of land immediately planted crops, both as a supplement to the family food supply and as a cultural link to the life left behind. The Tsapatsaris family farmed extensively on the acre-sized Mammoth Road lot. The Depression came early to Lowell. With tenants unable to pay rent, homeowners were unable to pay mortgages. At 2:00 p.m. on September 30, 1931, an auctioneer named Henry S. Anthony sold the Tsapatsaris property, foreclosing the mortgage held by the Lowell Institution For Savings. Nicholas continued working in the shoe shop, and the family relocated to rental housing back in the Acre. World War II brought jobs to Lowell. Nicholas remained in shoe manufacturing, and Julia found work at the Atlantic Parachute Company, as did their daughter Stella. Sons Peter (the Marines) and Charlie (the Army) both served in the Pacific while younger siblings remained in school (sons Steve, Michael, and George all served in the military during the Korean Conflict). With the added wages from wartime employment, Nicholas and Julia were able to purchase a home on Sargent Street in 1943. After the war, they continued to live and work in Lowell, he at Chris Laganis Shoe Company and she at Textron and then the Lowell Dress Manufacturing Company. Nicholas died in 1963; Julia died in 1987. Both are buried in Lowell. (Courtesy of George Tsapatsaris.)

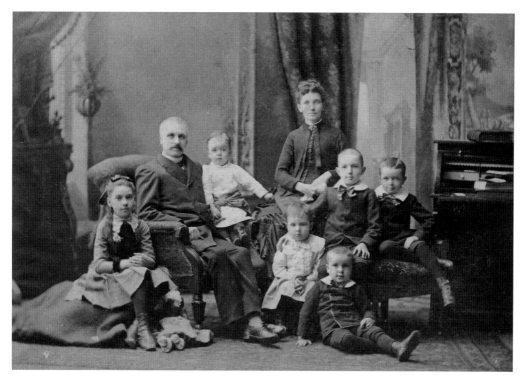

Bartholomew Scannell
Arriving from Ireland at age two, Bartholomew Scannell (1843–1920) spent his early years working in a variety of jobs until he entered the steam boiler manufacturing business, opening his own company in Lowell in 1880. Continued on by sons and grandsons, Scannell Boiler Works remains in business today. The photograph shows Bartholomew, his wife, Mary Ann, and their children. (Courtesy of JoEllen Scannell.)

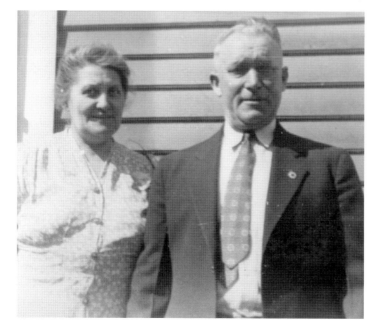

Hugh Francis Talty
Hugh Talty (1903–1955) joined the Harvard Brewery after the repeal of Prohibition. In operation since 1898, Harvard had a mixed legacy. During Prohibition, its officers were prosecuted due to the high alcohol content of its "near beer." During World War II, the company was seized and then operated by the federal government when its German owner was prosecuted as an enemy agent. Harvard Brewery closed for good in 1956. (Courtesy of Frank Talty.)

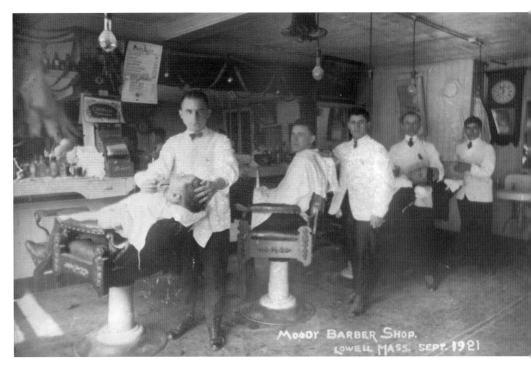

Arthur Voutselas

When 19-year-old Arthur Voutselas (1897–1973) arrived from Greece, he longed to be his own boss so he opened a barbershop located on the boundary of the Greek and French-Canadian sections of the Acre. The shop thrived as a business and as a neighborhood gathering spot. In 1959, his son, George, who continues to operate the business as the Majestic Barber Shop, joined Arthur. (Courtesy of George Voutselas.)

New England Telephone

On April 25, 1877, Alexander Graham Bell demonstrated his year-old invention at Lowell's Huntington Hall and convinced many city residents, led by Dr. Moses Greeley Parker, to invest heavily in the telephone company, which retains a substantial presence in the city today. This photograph shows telephone company employees, from left to right, Philip Linquist, Joseph Smith, and unidentified at the Appleton Street business office. (Courtesy of Mary Howe.)

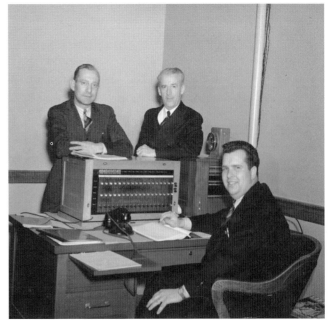

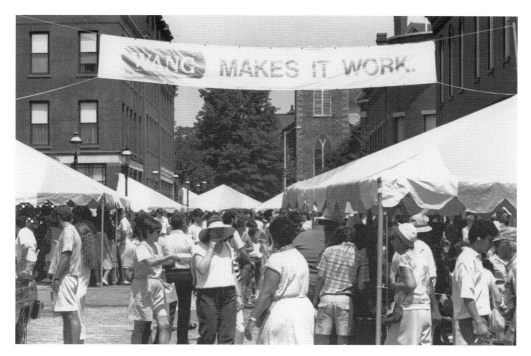

Wang Laboratories and Lowell

In 1976, computer-maker Wang Laboratories opened its international headquarters in Lowell, eventually building three office towers totaling 1.2 million square feet along with several manufacturing facilities and a six-story training center in the heart of downtown Lowell. Wang became a major regional employer and supported community events like the Lowell Folk Festival. (Courtesy of Kevin Harkins.)

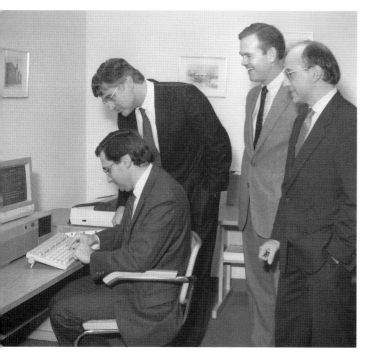

The Lowell Plan

Established in 1980, the Lowell Plan is a private, nonprofit organization that promotes economic development in Lowell. This early 1980s photograph shows, from left to right, executive director James Milinazzo, Wang vice president Paul Guzzi, Lowell Plan president Richard Alden, and president of the Lowell Development and Financial Corporation Walter Marcella exploring the capabilities of a state-of-the-art word processor from Lowell-based Wang Laboratories. (Courtesy of Kevin Harkins.)

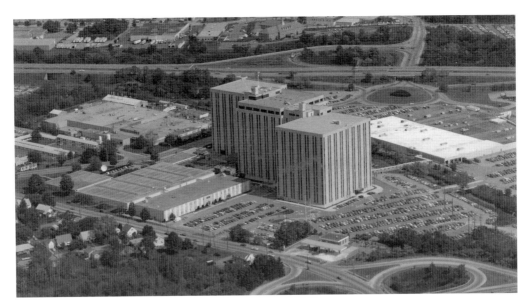

Wang Towers, Cross Point
The death of founder An Wang and changes in the computer industry caused Wang Laboratories to falter in the early 1990s. The company filed for bankruptcy, and in 1994, the Wang towers, which had cost $60 million to build and housed 4,500 workers, were sold at a foreclosure auction for $525,000. (Courtesy of Kevin Harkins.)

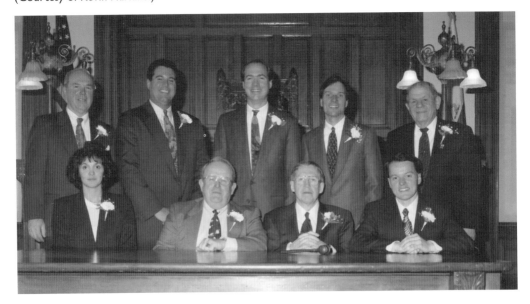

Lowell City Council
When NYNEX doubted the financial stability of the new owners of the former Wang towers and balked at leasing space, the Lowell City Council guaranteed the lease. NYNEX moved in, and by 1998, the towers, renamed Cross Point, sold for $110 million. The 1994–1995 city council members are, from left to right, (first row) Laurie Machado, Larry Martin, Mayor Richard Howe, and Stephen Gendron; (second row) Edward "Bud" Caulfield, Micheal Geary, Matthew Donahue, Grady Mulligan, and Tarsy Poulios. (Courtesy of Mary Howe.)

Lowell's Department Stores
Department stores were a major part of Lowell's business and social scene. Shown to the left is Doris Marion (1921–1989), a longtime employee at Cherry & Webb Department Store. The Bon Marche was perhaps the city's preeminent store. Opened in 1878, the Bon Marche suffered the fate of many independent department stores in 1976 when it was sold to Jordan Marsh, which subsequently closed it. Vacant for several years, local developers George Behrakis and Nick Sarris restored the building to its original grandeur with the assistance of the Lowell School Committee, which leased two floors for administrative offices. At the ribbon cutting in the photograph below are, from left to right, Mayor Richard Howe, George Behrakis, Robert Gilman of the Lowell Plan, and Nick Sarris. (Left, courtesy of Paul Marion; below, courtesy of Kevin Harkins.)

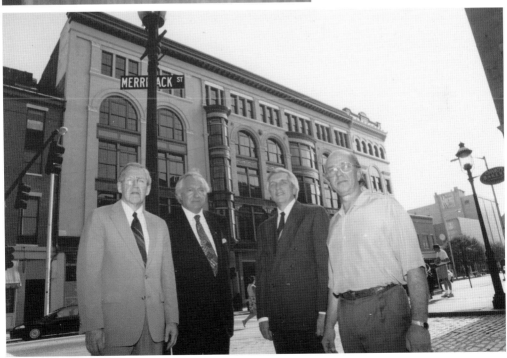

Kendall Wallace and Steven Panagiotakos

When Kendall Wallace (left) graduated from Lowell High in 1959, he assumed that he would follow his brother into banking. Instead, he landed a job as a copyboy at the *Lowell Sun* and has been with the paper ever since, serving as a reporter, city editor, managing editor, general manager, and then publisher. The *Lowell Sun* was born in 1878 when printer John Harrington decided Lowell needed a newspaper that gave voice to his fellow Democratic-leaning Irish immigrants and that provided an alternative to the pro-Republican papers already in circulation. It was an era in which local newspapers did not shy away from promoting projects or pursuing agendas. In that respect, the *Lowell Sun* that Kendall Wallace joined in 1959 had not changed much. Wallace cites many examples of projects in Lowell through the years that might not have succeeded without the strong support of the local newspaper, including the success of the Model Cities program, which laid the groundwork for the National Park; the school building program, which transformed the image of the Lowell schools; the expansion of UMass Lowell and Middlesex Community College; the construction of a downtown hotel, an arena, and a ballpark, which collectively changed the image of the city; the widening of Route 3, from Burlington to the New Hampshire line; and the Hamilton Canal project, which is transforming vacant mill space into the city's newest mixed business and residential development. These issues were not just promoted with an editorial or two; they were the constant focus of the newspaper both in print and behind the scenes. While the newspaper played a vital role in the success of these projects and many others, so did the men and women elected to represent Lowell in the General Court of Massachusetts. For decades, Lowell's state house delegation has been a key component of the delivery system that has brought millions of dollars in state and federal aid to Lowell. Steven Panagiotakos (right), a graduate of Harvard and Suffolk University Law School, was elected to the Lowell School Committee in 1989, the Massachusetts House of Representatives in 1992, and the state senate in 1996. In the senate, he quickly rose to the powerful post of chair of the Senate Ways and Means Committee. In that position, Panagiotakos, who did not seek reelection in 2010, played a crucial role in helping the commonwealth endure the global financial crisis, while at the same time keeping major state projects in Greater Lowell on track. (Courtesy of RPH.)

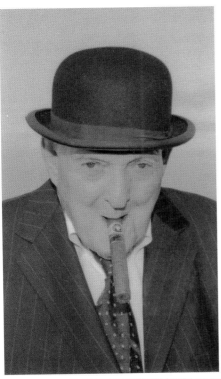

Leo D. Mahoney

Leo D. Mahoney (1928–2010) and his brothers oversaw the transition of Mahoney Coal, Coke & Ice to Mahoney Oil, which is still in business today. Leo was also president and cofounder of Eastern Minerals Incorporated, the largest supplier of road salt in the Northeast, with his daughter Shelagh succeeding him as president. Leo was a quiet but generous supporter of many charities in Lowell and around the world. (Courtesy of Mahoney family.)

Lowell Kiwanis Club

Since its founding in 1917, the Lowell Kiwanis Club has been one of many such organizations in Lowell that allows businesses and individuals to work together for the betterment of the community. This photograph shows, from left to right, Kiwanis members Norman Glasman (the Rialto and other theaters), Joseph Foley (Joseph J. Foley Jewelry Store), Walter White, Leon Abbott (Pratt & Forrest Lumber), and Kirke Dunlap (Dunlap Plumbing). (Courtesy of Rosemary Noon.)

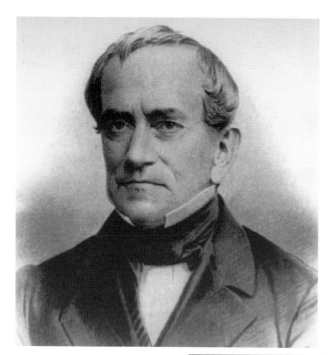

James Carney

Born in Boston, James Carney (1804–1869) moved to Lowell in 1828. He was one of the founders of the Lowell Institution for Savings and also the Lowell Cemetery. In 1858, Carney donated $200 to the city of Lowell to be used for medals to be awarded annually to the top six graduates—three male and three female—at Lowell High School. The Carney Medals continue to be awarded today. (Courtesy of CF.)

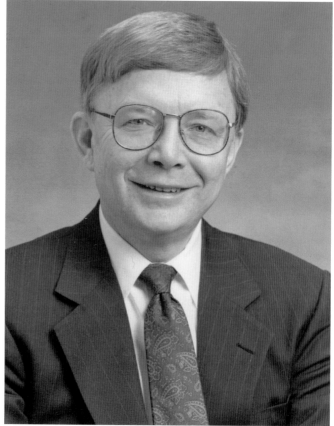

George Duncan

After graduating from Lowell High in 1957, George Duncan obtained an entry-level position in a local bank. Thirty years later, he founded Enterprise Bank, an independent, innovative financial institution that not only provides traditional banking services but also is intimately involved in the life of the community. George Duncan set the example by serving on countless boards and committees of professional, civic, and cultural organizations for more than 40 years. (Courtesy of Kevin Harkins.)

CHAPTER THREE

Community

As the workforce of Yankee mill girls gave way to wave upon wave of immigrants, so the paternalistic system of boardinghouses gave way to residential neighborhoods. Through a series of annexations from surrounding communities, the city's footprint expanded substantially. Each neighborhood developed its own distinct identity but all had common characteristics. The building block of each was the family. Immigrants arrived with nothing and so everyone worked out of necessity. Few owned homes; most became tenants in multifamily housing. Living in close proximity in relative poverty drew families and neighbors close together. Because not every family arrived intact, immigrant groups created social clubs to provide a network of support for their respective communities. Religion also played a vital role in family life, providing for individual spiritual needs but also for the social well-being and self-esteem of members of the community. While most of the newcomers to Lowell worked in the city's mills, some started their own businesses, often small grocery stores that were essential to everyday subsistence. Education was highly valued with the most talented child often allowed to pursue advanced study with the financial support of parents and siblings. Rather than flee the city, these privileged individuals returned as doctors, lawyers, educators, or public servants, determined to give back to the community that had given so much to them. Lowell has always taken great pride in its public schools, particularly the city's single high school. Established in 1831, Lowell High was, from the very beginning, open to all regardless of race or gender. In an age before television and the internet, high school sports became prime sources of entertainment and local pride. In recent years, the city's two institutions of higher learning, Middlesex Community College and University of Massachusetts Lowell, have become leaders in innovation and community building. Throughout it all, the people of Lowell have demonstrated a generosity of spirit and a devotion to each other that provides a solid civic foundation for all other activities and enterprises.

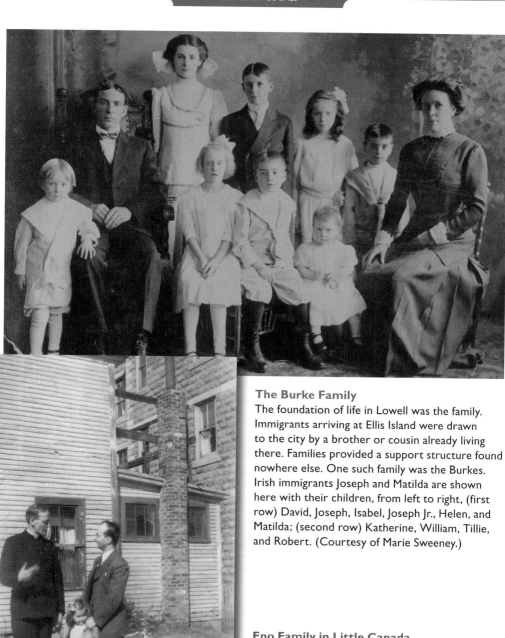

The Burke Family

The foundation of life in Lowell was the family. Immigrants arriving at Ellis Island were drawn to the city by a brother or cousin already living there. Families provided a support structure found nowhere else. One such family was the Burkes. Irish immigrants Joseph and Matilda are shown here with their children, from left to right, (first row) David, Joseph, Isabel, Joseph Jr., Helen, and Matilda; (second row) Katherine, William, Tillie, and Robert. (Courtesy of Marie Sweeney.)

Eno Family in Little Canada

Camille Eno and his daughter Frances chat with Fr. Joseph Dessy on Race Street in Little Canada in 1948. A few years later, this well-established ethnic neighborhood was bulldozed in the name of Urban Renewal, a federally funded program intended to reverse trends in decaying housing stock and poverty. Whether the gains of Urban Renewal outweighed the loss of such neighborhoods is still debated today. (Courtesy of Leon Eno.)

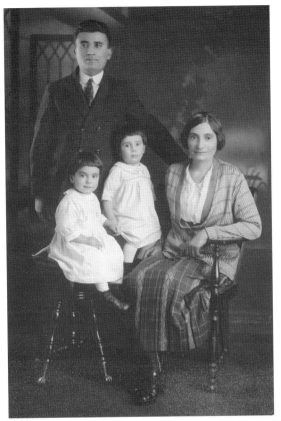

Narzakian Family

Michael Narzakian (1888–1948) came to America from his native Armenia in 1908. Because the Armenian genocide began after he left, he could not return, and it took 10 years for him to be reunited with his wife, Lucy (1890–1984). In 1921, their twins Harry (1921–2007) and Rose (1921–present) were born. Michael operated a small grocery store on the corner of Central and Ames Streets. His customers were not only Armenians but also the many Portuguese immigrants who lived in the neighborhood. When asked why so many immigrants of all nationalities opened grocery stores, Rose suggested that most immigrants are entrepreneurs who want to be independent while also helping their community. The photograph below shows the interior of the store. (Courtesy of Rose Narzakian.)

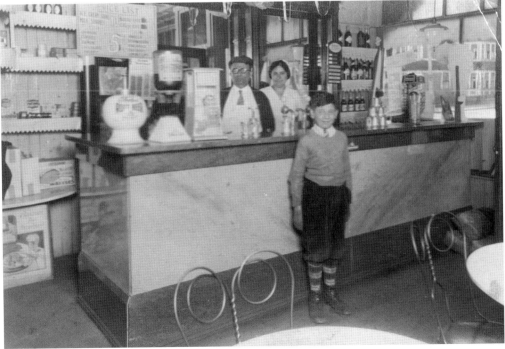

Quealey's Store

When David Quealey (1898–1956) came from Ireland in 1924, he settled in Dorchester and worked for First National grocery stores. In 1940, he moved to Lowell to manage one of the chain's small neighborhood stores. After World War II when the company consolidated into a few large stores, David took over the First National lease and operated the store at 99 South Whipple as Quealey's. When David died, his wife Margaret and sons John and Joe took over the store, which served as a multigenerational meeting place for the South Lowell neighborhood. The photograph below shows the 1976 baseball team sponsored by Quealey's with, from left to right, (front row) Neil Murphy and Ralph Silva; (middle row) Marty Meehan, Bill Murphy, and Bart McAndrews; (back row) John Quealey, Brian Sheehan, Jim Neary, Matt McCafferty, and Joe Quealey. (Courtesy of John Quealey.)

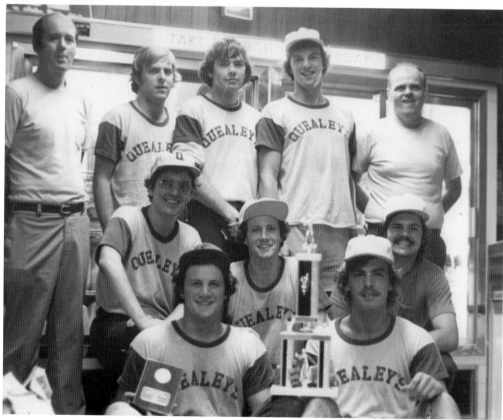

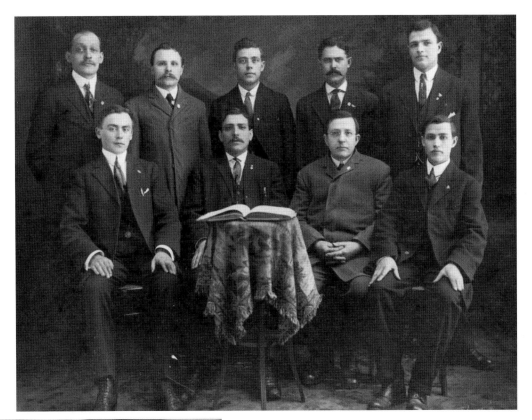

Dom Polski

Polish immigrants formed "Dom Polski," The Polish National Home Association, in 1910 with Stanislaw Wozniak (seated, second from left) as its first president. For nearly a century, Dom Polski has served the Polish community in Lowell by offering a place to socialize and to hold important events while helping to preserve the Polish culture. In this, Dom Polski is emblematic of the role played by ethnic social clubs for all of Lowell's immigrant communities. (Courtesy of Pauline Golec.)

Maria Cunha

Seeking better educational opportunities for their children, Maria Cunha's parents moved the family to America from their native Azores when Maria was 12 years old. Unlike many of her contemporaries who left school early for work, Maria graduated from Regis College and went to work at Lowell's International Institute where she assisted the city's successive immigrant groups with the challenges of citizenship, education, and daily life in a new community and country. (Courtesy of Kevin Harkins.)

St. Patrick's Parish

In an immigrant community like Lowell, churches of all denominations provided for spiritual needs but also served the social welfare of the community. Dedicated in 1831, St. Patrick's was Lowell's first Catholic church. Fr. John O'Brien arrived as pastor in 1848 at a time of massive Irish immigration. He, his brothers, and his nephew all served the parish as priests and saw the Irish rise to prominence in Lowell. In 1852, five Sisters of Notre Dame de Namur arrived and established a girls' academy, which eventually moved to Tyngsborough as Notre Dame Academy. By their actions and example, the nuns imposed on congregants a lasting parish-wide obligation to assist the poor and the sick. (Courtesy of Dave McKean.)

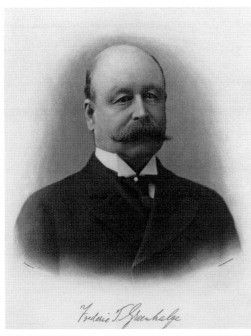

Frederic T. Greenhalge

Born in Clitheroe, England, Frederic Greenhalge (1842–1896) came to Lowell when his father was hired as the master cloth printer at the Merrimack Mills. Forced to drop out of Harvard to support his family after the death of his father, Frederic worked first as a teacher and then as a lawyer. Entering politics, he served on the school committee, as mayor, in Congress, and, in 1894, as governor of Massachusetts. A leading advocate of public education, Greenhalge maintained that, "a free Commonwealth can only rest upon the foundation of a free public school." Reelected twice by overwhelming margins, Greenhalge died in office in 1896 at age 52. Below are some of the beneficiaries of his education policies— the first grade class at the Morey School in 1938. (Left, courtesy of State Library of Massachusetts Special Collections Department; below, courtesy of Mary Howe.)

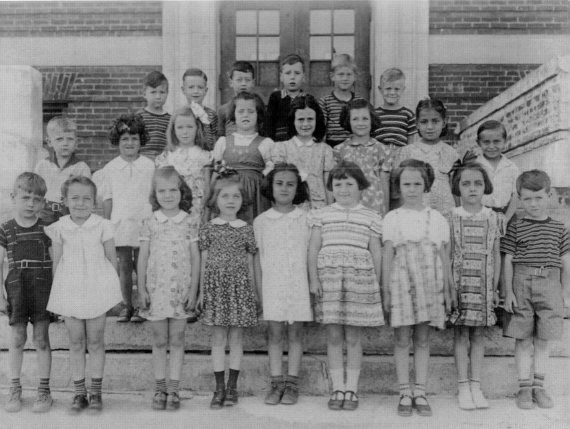

George Tsapatsaris

Several decades as a classroom teacher and school administrator, plus early experience as an Army officer and as the manager of the family restaurant, made school superintendent George Tsapatsaris (1930–present) the perfect person to implement a complex school desegregation plan and to oversee the construction of a dozen new schools. This son of Greek immigrants made the equitable treatment of all students and increased parental involvement top priorities during his tenure. (Courtesy of George Tsapatsaris.)

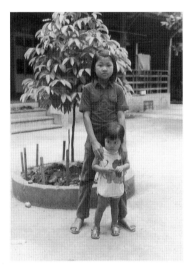

Phala Chea

Escaping the Killing Fields of Cambodia, Phala Chea and her family came to Lowell in 1987 via Portland, Oregon. Unsure of a career while in college, school superintendent George Tsapatsaris urged Phala to become an educator. She did and is now an administrator in Lowell public schools with a doctorate in education from UMass Lowell. She is shown to the right with her younger sister Phakdey Chea in a refugee camp in Thailand. (Courtesy of Phala Chea.)

Richard P. Howe (OPPOSITE PAGE)

Richard P. Howe (1932–present) was born in Lowell in the midst of the Depression. Growing up, his passion was baseball; the competitiveness so evident in sports carried over to the courtroom, where he practiced law for nearly 50 years. In the fall of 1965, Howe was elected to a two-year term on the Lowell City Council. He was reelected 19 consecutive times and served 40 years on the city council, more than anyone else in the city's history. On the council, he was the voice of fiscal restraint, often in the minority, and never hesitated to engage in vigorous debate. Howe also served four two-year terms as mayor (1970, 1988, 1990, and 1994). His lengthy council career came to an end when he chose not to seek reelection in 2005. When Howe was elected mayor in January 1988, he faced an immediate crisis. A lawsuit being prosecuted by the US attorney on behalf of parents of minority students claiming inequitable treatment was advancing through the US District Court in Boston where Judge Robert Keeton was about to order a federal takeover of the Lowell public schools due to the failure of the school committee to implement a desegregation plan. Appearing before the judge along with school superintendent George Tsapatsaris and city solicitor Tom Sweeney, Mayor Howe, an experienced trial attorney, pleaded with the judge to delay the takeover to give him and the newly elected school committee a chance to work things out. Over the government's objection, Judge Keeton granted a continuance. Meeting repeatedly with lawyers representing the parents, Tsapatsaris, Sweeney, and Howe negotiated a solution that was acceptable to the parents, the school committee, and the judge. The takeover was averted and the city implemented a "controlled choice" desegregation plan that continues in effect today. As a consequence of the new plan, the city of Lowell jumped to the top of the state's school building assistance program. Under the exceptional leadership of Tsapatsaris, more than a dozen state-of-the-art schools replaced public schools that had been built during the Polk administration, with the commonwealth reimbursing 90 percent of the cost of construction. (Courtesy of Mary Howe.)

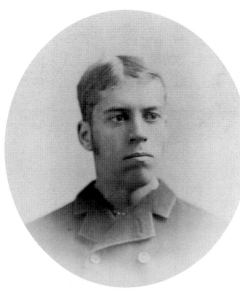

Cyrus W. Irish

When he returned to Lowell High (LHS class of 1881) after graduating from Harvard, Cyrus Irish's youthfulness often caused him to be mistaken for a student. Passionate about science, he "made chemistry fascinating to every student who took it up." After publishing a science textbook in 1899, Irish was named headmaster of the high school, a position he held until his death in 1917. The Lowell High auditorium is named in his honor. (Courtesy of Lowell High School.)

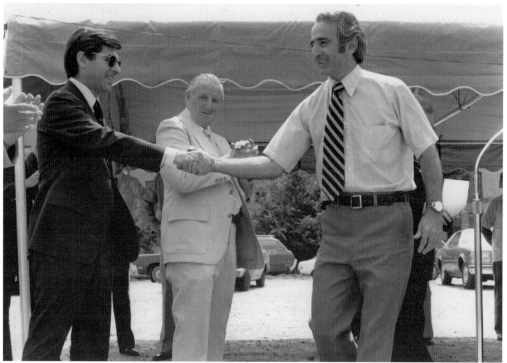

Peter S. Stamas

A graduate of Lowell High and Harvard, Peter Stamas (1930–2002) first taught in Dracut but then joined the Lowell Model Cities Program led by Patrick Mogan, where together they helped lay the foundation for the Lowell National Park. In 1974, Stamas became submaster and in 1975 headmaster of Lowell High. This photograph is of the ground breaking for the 1980 addition to the school. From left to right are Gov. Michael Dukakis, school superintendent Patrick Mogan, and Peter Stamas. (Courtesy of Lowell High School.)

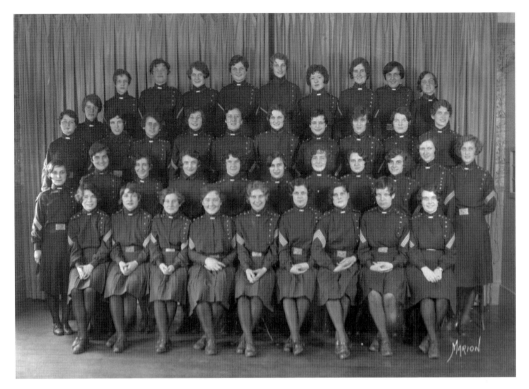

Lowell High School Girl Officers

After the Civil War, Lowell High School began providing military training to male students. A corresponding program for young women, the Girl Officers, was instituted in 1893. Girl Officers were seniors who led gym classes, held dances, raised funds for charity, and organized Field Day each spring. Selection of each year's group of Girl Officers was a major event for the entire city. The Girl Officers program ended in the 1980s. (Courtesy of Lowell High School.)

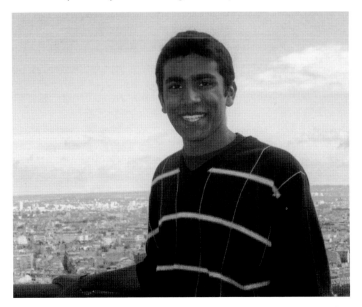

Palak Patel

Since its founding in 1831, Lowell High School has promoted academic excellence. In 1999, the school established the Lowell Latin Lyceum, a highly competitive exam school within the high school that emphasizes a classical education. Palak Patel graduated from the Lyceum in 2007 as the high school valedictorian and senior class president. He went on to graduate from Harvard in 2011. (Courtesy of Nitin Patel.)

Raymond E. Riddick

Lowell High had always had a strong football tradition but when Ray Riddick (1917–1976) became coach in 1947, the program became a nationally recognized power in high school football. A Lowell High graduate who played at Fordham alongside Vince Lombardi, Riddick played several seasons with the Green Bay Packers before returning to Lowell where he coached football until his death in 1976. The Lowell High Field House is named in his honor. (Courtesy of Lowell High School.)

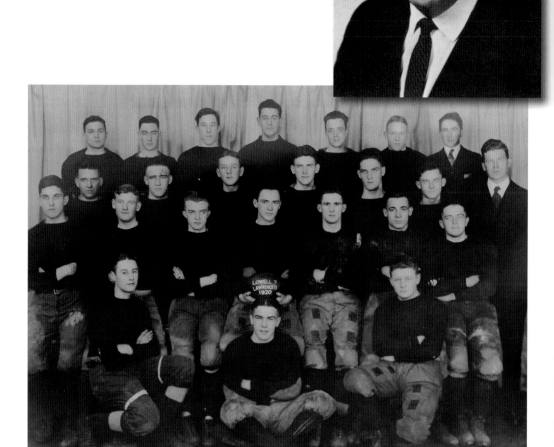

Lowell High Football Team

Pictured is the Lowell High School 1920 football team. Members, from left to right, are: (first row) Timothy "Buck" O'Keefe, Franklin Trull, and George "Red" O'Hare; (second row) Brendon "Benny" McAdams, Edward "Ned" Condon, Thomas "Harper" O'Day, John J. "Gus" Cahill, Gregory "Geg" McAdams, Lester B. "Abie" Holt, and James Howe; (third row) Emmett Winters, Spencer Sullivan, John McMannamon, Fred Ryan, Raymond Liston, Sam Rowlandson, and coach James F. Conway; (fourth row) William J. "Bucky" O'Neil, Fred "Ziskind" Gleason, William "Chisel face" Brosnan, Gus Normandin, Lorenzo "Lull" Goddu, Earnest Dodge, and manager Francis Byrne. (Courtesy of Carol Collins.)

Marty Meehan

When Marty Meehan became chancellor of University of Massachusetts Lowell in the summer of 2007, few anticipated the scale of the transformation the school would undergo so early in his tenure. One of five campuses of the UMass system, Lowell is a comprehensive national research university that has become a leader in teaching, research, and community engagement, both local and global. At a time of fiscal austerity, Meehan has made the school more entrepreneurial, with fund raising up 84 percent since he became chancellor. A native of Lowell, Meehan graduated from Lowell High and UMass Lowell and holds advanced degrees in law and public policy from Suffolk University. Elected to Congress in 1992, Meehan became a champion of campaign finance reform during his 15 years in Washington and was one of the chief sponsors of the 2002 Bipartisan Campaign Reform Act, called Shays-Meehan in the House and McCain-Feingold in the Senate. Meehan's announcement in March 2007 that he would resign his seat in Congress to join UMass Lowell triggered a special election that was won by Niki Tsongas, whose late husband, Paul, held the seat from 1974 to 1978. In UMass Lowell, Meehan took charge of a school with a long heritage in the city. While it did not join the UMass system until 1991, the school that exists today was formed in 1975 as University of Lowell with the merger of Lowell State College and Lowell Technological Institute. Lowell State was founded in 1894 as Lowell Normal School with a mission of preparing elementary school teachers. In 1932, its name was changed to State Teachers College at Lowell. Lowell Tech was founded in 1895 as Lowell Textile School, offering training in cotton and wool manufacturing and dyeing. In 1929, it became Lowell Textile Institute and in 1953, Lowell Technological Institute. UMass Lowell has long been integral to the success of its home city, something more true today than ever before. While continuing to provide higher education to thousands of Lowell residents, the recent acquisition by UMass Lowell of a struggling downtown hotel for its inn and conference center and its takeover of the multipurpose Tsongas Arena make the university a major player in the daily life of downtown Lowell and a key ingredient in the city's embrace of the cultural economy. (Courtesy of UMass Lowell.)

Carole Cowan

A native of Lynn who anticipated a secretarial career at the General Electric plant, Carole Cowan began teaching business at Middlesex Community College in 1976. Twenty-four years later, with advanced degrees from Salem State and a doctorate from UMass Amherst, she became president of the college. Under her leadership, MCC's City Campus in Lowell has flourished, expanding into formerly vacant buildings and contributing to the betterment of Lowell in countless ways. (Courtesy of Kevin Harkins.)

Lowell: A College Town

Built by Wang as its worldwide training center, the company's collapse left the building at left vacant until Middlesex Community College made the structure the center of its city campus. Built as a Hilton Hotel to house the Wang trainees, the building at right struggled for decades until UMass Lowell made it the school's inn and conference center. Together, these two reuses have helped transform Lowell into a college town. (Courtesy of RPH.)

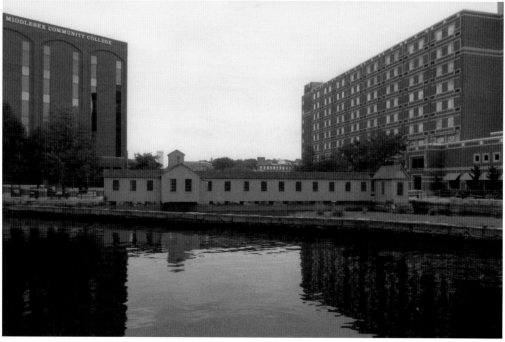

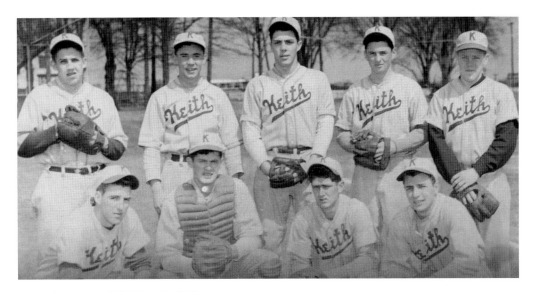

Keith Academy 1950 Baseball Team
Opened in 1926 by the Xaverian brothers in the former county jail, Keith Academy was an all-boys high school that always fielded competitive athletic teams. This photograph shows the starters of the 1950 Keith baseball team, from left to right, (first row) Capt. Hank Powell, Coley Day, Hugh McKenney, and Ken Delisle; (second row) Dick Howe, Dan Leahy, Len Toomey, Charles Mellen, and Bob Foley. Keith closed in 1970; however, its legacy continues at Lowell Catholic High School. (Courtesy of Mary Howe.)

Paul E. "Bubby" Regan
Among the star athletes to play at Keith Academy was Paul E. "Bubby" Regan (1936–1957) who starred in baseball and football and also was elected president of the student body. His athletic accomplishments in high school were widely reported in the local press. Regan went on to play varsity baseball at Providence College, but his life was cut short by stomach cancer after his sophomore year. (Courtesy of Dave Slattery.)

George Francis "Frank" Sargent
While a student at Boston College, Frank Sargent (1912–1968) asked the *Lowell Courier Citizen* to hire him to cover Red Sox and Braves games for the paper since he was in Boston anyway. Lacking such coverage of Boston sports, the newspaper agreed, and a sports-writing career was born. After Naval service in World War II, Frank switched to the *Lowell Sun*, covering games of all types and writing a column called *The Lookout*, which provided extensive commentary on local sports and athletes along with analysis of the pros (including Ted Williams, seated in the photograph at right). In December 1947, Frank appealed to readers for gifts for needy families at Christmas. This practice grew and grew, with the family's Chauncey Avenue home serving as a warehouse in the days leading up to Christmas. Frank died in 1968 after attending spring training with the Red Sox. He was only 55. (Courtesy of Jeannie Judge.)

Lowell Lodge of Elks Track Team

Lowell has a long tradition of track meets and road racing that extends through Jack Kerouac, who ran track at Lowell High, to the Greater Lowell Road Runners, one of the most prominent running clubs in New England. The above photograph shows the track team sponsored by the Lowell Lodge of Elks in 1926, featuring, from left to right, (first row) Joe Sweeney, Bob "Dutchy" Burke, and Joe Slavin; (second row) Jimmy Daley, James Donnelly, Whit Pearson, Fred Gilmore, and Sy Dean. Sweeney became a well-known Lowell physician, while Daley became an educator; he is the namesake of the Daley Middle School. The photograph below shows a March 3, 1926, track meet on the south common. Joe Sweeney wears no. 2. (Courtesy of Bill Sweeney.)

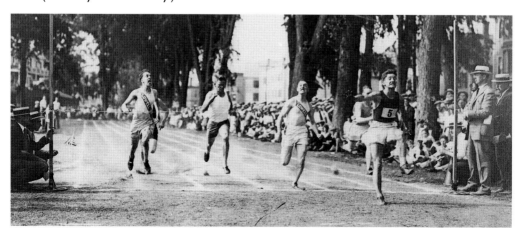

Hampton Beach
Many Lowell families have a deep affection for Hampton Beach. Its origin lies in a fear of polio. The risk of that devastating disease was thought to be greatly diminished by ocean water and air, so those who could relocated to the New Hampshire seashore in summer. Hardly a hardship, the ritual of summers at Hampton continued even after polio vaccine removed the risk. The photograph shows Frank and Eileen Sargent at Hampton Beach. (Courtesy of Jeannie Judge.)

1952 Keith Academy Golf Team
From left to right are Larry Stowell, Larry Martin, Gardner Brooks, Tom Mulligan, Chick Loucraft, John Killoy, and Frank Grady. While golf was often the domain of the upper class, many working class kids in Lowell were introduced to and found a passion for golf while caddying. The annual Lowell City Golf Tournament remains one of the sporting and social highlights for many longtime residents. (Courtesy of the Loucraft family.)

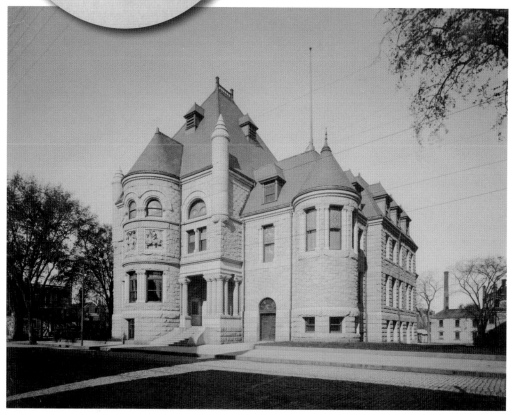

Frederick Stickney and Memorial Hall

A Lowell native and MIT-trained architect, Frederick Stickney (1853–1918) was selected over dozens of others in 1891 to design the city's new library, which would be known as Memorial Hall, in honor of those who had died during the Civil War. The granite structure has provided generations of Lowell residents with a place of learning and entertainment. Jack Kerouac maintained that his real education came at the city library, which he described in his novel *Doctor Sax*: "All the night before I've been dreaming of books—I'm standing in the children's library in the basement, rows of glazed brown books are in front of me, I reach out and open one—my soul thrills to touch the soft used meaty pages covered with avidities of reading—at last, at last, I'm opening the magic brown book." (Left, courtesy of CH; below, courtesy of Library of Congress.)

Edward Hosmer

When Edward Hosmer (1837–1919) retired on May 1, 1913, he had spent the previous 55 years as a firefighter, 30 of them as chief of the Lowell Fire Department. Under his leadership, the LFD became a modern department, transitioning from hand engines to steam and from horse-drawn to motorized apparatus. As early as 1880, Hosmer called for building safety codes and mandatory fire inspections. (Courtesy of IHL.)

Edward F. Davis III

Ed Davis rose through the ranks of the Lowell Police Department to become superintendent after 16 years on the force. During the 12 years he led the department, Davis stressed community policing, which brought officers into closer contact with the community they served. In 2006, Ed Davis left Lowell to become the police commissioner of the City of Boston. (Courtesy of Kevin Harkins.)

Gorman Family

The 1904 photograph to the left shows Michael and Susan Gorman and their daughters, from left to right, Alice, Nellie, Nora, and May. A year after the photograph was taken, the following notice appeared in the local newspaper: "GORMAN—The many friends of Mr. and Mrs. Michael Gorman will be pained to learn of their double bereavement in the loss of two children by death yesterday. Susan, aged 1 year and 14 days, and May, aged three years, dying within a few hours of each other, after a brief illness at the home of their parents, 154 Cross Street. Owing to the cause of death, diphtheria, the funeral took place this morning at 10 o'clock in charge of Undertakers J.F. O'Donnell & Sons. Interment was in the Catholic Cemetery." Losses such as this helped speed the modernization of municipal sanitation and water services in communities like Lowell. The photograph below is the Lowell Water Department office. (Left, courtesy of Mary Howe; below, courtesy of public CH.)

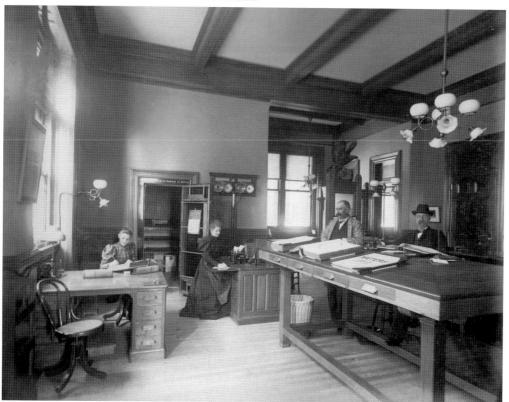

Joseph D. Sweeney

A ruptured appendix in boyhood created a lifelong fascination with medicine in Joseph Sweeney (1905–1982). After graduating from Boston College and Tufts Medical School, Sweeney served the city of Lowell in many capacities. He was chief of surgery at St. John's Hospital, the chair of the city's Health Department, and the medical examiner for the Northern Middlesex Region. A typical day for Dr. Sweeney began with morning surgery (as in the photograph below, assisted by Dr. John Barry), afternoon office appointments, and dinner at home, after which he would load his own children in the car to accompany him as he made evening house calls around their South Lowell neighborhood. Such evenings often ended at the soda fountain of Campbell's Drug Store. The City of Lowell dedicated a South Lowell park in his honor. (Both courtesy of Bill Sweeney.)

Mary Bacigalupo and Marie Sweeney
While the city of Lowell has produced many leaders in business, politics, and various other fields, much of the city's success is traceable to the quiet, behind-the-scenes work of activists such as Marie Sweeney and the late Mary Bacigalupo (1942–2001). As mentors and advisors to a generation of local leaders and through their own service on countless boards and committees, both Mary (left) and Marie (right) have done much to improve the lives of Lowell's citizens, especially those most in need. (Courtesy of Marie Sweeney.)

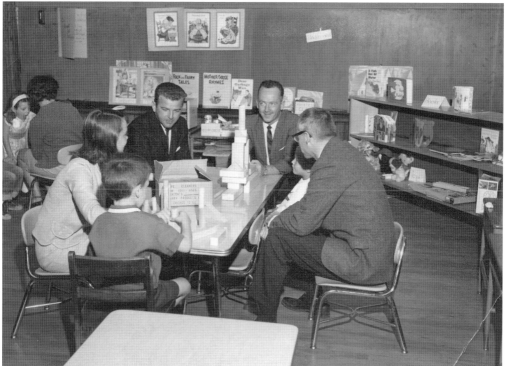

Community Teamwork, Head Start
Established in 1965, Community Teamwork Incorporated (CTI) is a private, nonprofit community action agency established as part of Pres. Johnson's War on Poverty. The mission of CTI is to provide training, education, and assistance to low-income people so that they may become self-sufficient. This photograph shows the opening day of CTI's Head Start program. (Courtesy of CTI.)

Grandmother Holding
Baby Contover, 15 Day's Old

Edward Carney

When Arthur Solomonides, a painter of religious icons in Greece and a dye house worker in a Lowell mill, died suddenly leaving his wife, Helen, and five children under the age of seven, Edward Carney (above), the treasurer of the Lowell Institution for Savings, arranged for the Museum of Fine Arts to purchase some of the late Solomonides's works and made sure the children received presents at Christmas. When Helen Solomonides fell ill, Carney and his wife not only arranged for her treatment at Lowell General Hospital but also hired a nanny to care for the children during her convalescence. While there was undoubtedly ethnic strife in Lowell, there were also plenty of people like Edward Carney whose kindness and generosity transcended traditional boundaries of class, religion, and ethnicity. The photograph to the left is a later image of Helen Solomonides (1890–1955) with her grandson Dean Contover. (Both courtesy of Sylvia Contover.)

CHAPTER FOUR

Service

On a small patch of grass wedged between two busy streets in front of Lowell City Hall sits a 25-foot-high granite obelisk. Few passersby know that this monument commemorates 17-year-old Luther Ladd and 22-year-old Addison Whitney, two Lowell mill workers who were among the first soldiers killed in the Civil War. Fewer still realize that the two soldiers are actually buried there, right in front of City Hall. Responding to President Lincoln's call for volunteers to put down the rebellion, Ladd and Whitney died on April 19, 1861, when their regiment, the 6th Massachusetts Volunteer Infantry, was attacked by a mob of Southern sympathizers while passing through Baltimore on their way to Washington. At the time, Ladd and Whitney were called "the first martyrs of the great rebellion." Thousands more from Lowell served in the Civil War and in subsequent conflicts. The stories of some, like George Charrette, who during the Spanish-American War volunteered to sail a ship into the teeth of the defenses of Santiago Harbor in an attempt to trap the Spanish Fleet, or Edwin Poitras, who parachuted into Normandy in civilian clothes five weeks before the D-Day invasion to support the French Resistance, read like can't-put-down adventure novels. Most simply answered the call to duty when it came, and when their tour was complete, returned to Lowell to resume civilian careers in a community that gratefully acknowledged their status as veterans. Service in Lowell has never been limited to those who have worn military uniforms. Many in the city, both recent arrivals and longtime residents, devote countless hours to charitable and service organizations as a way of quietly giving back to the community. Often the most generous are those with the least available to give. Others serve in elected office, receiving minimal stipends for long hours, guiding the city through challenging times. Foremost among these may have been Paul Tsongas, who started on the city council, served in the House and the Senate, and then ran for president, after which he became not a Washington lobbyist but the preeminent advocate of Lowell right from his home on Mansur Street.

Chauncey Knapp

Chauncey Knapp came to Lowell from his native Vermont in the 1840s to serve as editor of an antislavery journal called *The Middlesex Standard*. Elected to Congress in 1854, he returned to Lowell in 1859 and spent the next 23 years as editor of the *Lowell Daily Citizen* newspaper. One of many in Lowell who vociferously opposed slavery, Knapp represents the complexity of that issue in a city whose economy was almost totally dependent on Southern cotton. (Courtesy of Library of Congress.)

Gustavus Fox

A graduate of Lowell High and Annapolis, Gustavus Fox (1821–1883) led the April 1861 Naval expedition to relieve Fort Sumter that precipitated the Confederate bombardment. As assistant secretary of the Navy, Fox was an early advocate of the USS *Monitor* and donated a chunk of that ship's armor to the city library after the war. After Fox led a delegation to Moscow in 1866, the czar's son visited Fox in Lowell. (Courtesy of Library of Congress.)

Benjamin F. Butler

A prominent lawyer and politician who served in Congress, ran for
president, and was governor of Massachusetts, Ben Butler is perhaps
best remembered for his Civil War military service. Convinced
that war was imminent, Butler brought the Massachusetts militia
to a high state of readiness before the war began.
As commander of Fort Munroe, Butler's deft
handling of escaped slaves—he deemed them
"contraband of war subject to forfeiture"—
set Union policy and paved the way for
the Emancipation Proclamation. Butler's
harsh treatment of civilians while military
governor of New Orleans earned him
the lasting enmity of Southerners, and
he was later relieved of command for
botching the amphibious assault on
a Confederate stronghold named Fort
Fisher. Butler died in Washington, DC, in
1893 at age 74. He is buried in the Hildreth
Family Cemetery in Lowell. (Main image,
courtesy of Library of Congress;
inset, courtesy of State Library
of Massachusetts Special
Collections Department.)

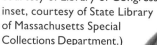
Governor of Massachusetts, 1883 to 1884.

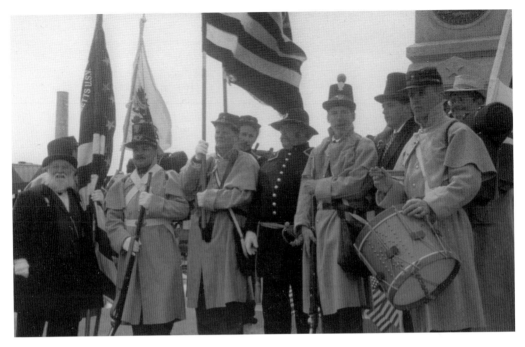

Ladd and Whitney Monument

Luther Ladd and Addison Whitney were two young mill workers from Lowell who were killed by a pro-Southern mob in Baltimore on April 19, 1861, as their unit, the 6th Massachusetts Volunteer Infantry, made its way to Washington. They and two comrades were the first killed by hostile fire in the Civil War. This photograph shows the rededication of the Ladd and Whitney monument by the City of Lowell in 2000. (Courtesy of RPH.)

Lowell City Library Sculpture

Historian Stuart McConnell wrote that "the Civil War experience hung over the post-war North in a thousand different ways." This was especially true in Lowell, where more than 5,000 served during the war. This photograph is of the facade of the city library, constructed in 1893, and originally called Memorial Hall in honor of those who died during the Civil War. The building was renamed the Pollard Memorial Library in the 1980s in honor of former mayor and city councilor Samuel Pollard. (Courtesy of CH.)

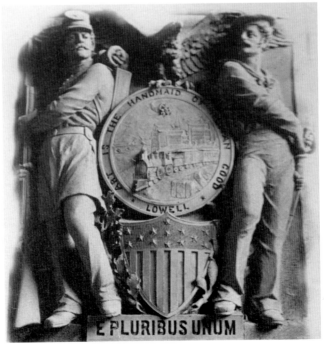

George Charrette

Early in the Spanish American War, George Charrette and eight other sailors volunteered to steam an old cargo ship into the entrance of Santiago Harbor and sink it, thereby trapping the Spanish fleet. Pummeled by enemy fire, the ship sank prematurely, but the volunteers all survived and were each awarded the Medal of Honor. Charrette remained in the Navy until his 1925 retirement and lived in Lowell until his death in 1938. (Courtesy of HOB.)

Charles Herbert Allen

After a term in Congress, Charles Herbert Allen (1848–1934) returned to Lowell to manage his father's lumber company. When the Spanish American War began, Allen became assistant secretary of the Navy and then the first US governor of Puerto Rico. He subsequently returned to Lowell and devoted himself to painting and gardening. The Allen House, with its superb views of the Merrimack River, now serves as the office of the chancellor of UMass Lowell. (Courtesy of Library of Congress.)

Irving Loucraft

A sergeant in Company M, 101st Infantry, 26th Division, and a recipient of the Silver Star and two Purple Hearts, Irving Loucraft (1899–1952) described his experience in a letter home: "We had quite a fight over here and the men in Co. M showed the boche that they were there all right, although we lost the best lieutenant in the regiment and Ma, he died in my lap. Just think of it!" (Courtesy of the Loucraft family.)

Edward McNerney

A native of Lowell, Edward McNerney (1895–1959) was awarded the Distinguished Service Cross and the Purple Heart while serving as First Sergeant of Company K, 104th Infantry, 26th Division in France in the summer of 1918. After the war, McNerney studied forestry and moved his family to Texas. Four of his children served in the military: Edward and Ruth in World War II and Richard and David in Vietnam. (Courtesy of Kathleen Kress Hanson and Eileen Kress.)

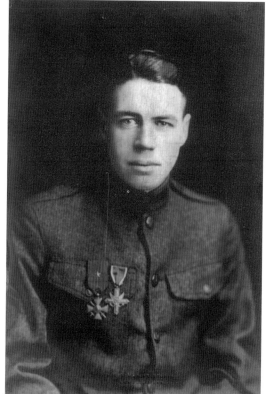

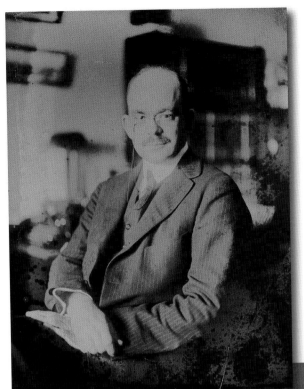

John Jacob Rogers
While practicing law and serving on the Lowell School Committee, John Jacob Rogers (1881–1925) was elected to Congress in 1912, serving there until his sudden death in 1925, when he was succeeded by his wife, Edith Nourse Rogers. During World War I, Rogers enlisted in the US Army as a private. After the war, he was the chief sponsor of the Rogers Bill, which created the modern Foreign Service of the United States. (Courtesy of Library of Congress.)

Edith Nourse Rogers
After the sudden death of her husband, John Jacob Rogers, in 1925, Edith Nourse Rogers succeeded him in Congress and served until her death in 1960. Though a Republican, she was a strong supporter of Roosevelt's New Deal. During World War II, she sponsored the legislation that created the Women's Auxiliary Army Corps (WAAC) and helped draft the GI Bill, which established financial and educational benefits for veterans. (Courtesy of Library of Congress.)

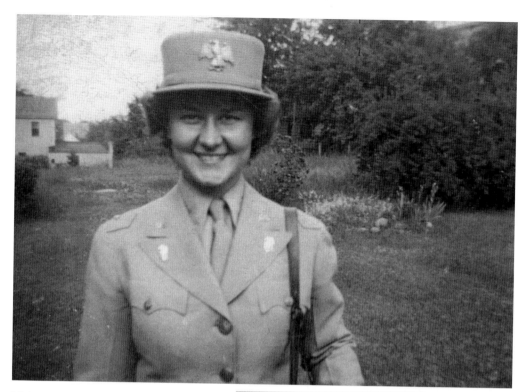

Helen Mangan Brooks

Helen Brooks (1921–present) enlisted in the Women's Army Corps and after basic training, was selected for Officer Candidate School. Commissioned a lieutenant, she worked directly for Army chief of staff George C. Marshall at the Pentagon. Taking the Army bus from her barracks to work on her first day, she took the only open seat, which was in the rear between two African-American enlisted men. The bus driver refused to move the bus until she moved from the seat. Months later, while delivering top secret documents to the White House, she was asked by President Roosevelt how she liked Washington. She shared her dismay over the discrimination evident in the bus incident. He replied, "It takes time to change how some people think." After the war, Helen, who attained the rank of captain, left the military and worked for the Veterans Administration in Boston. (Above, courtesy of Helen Mangan Brooks; right, courtesy of Janet Lambert Moore.)

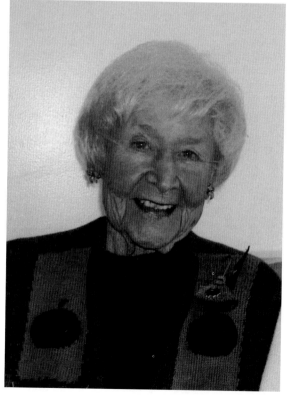

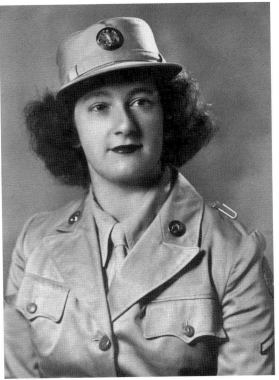

Elgy Solomonides Tuory

During the Depression, jobs were scarce, but the onset of World War II brought new employment opportunities to Lowell. Young women like Elgy Solomonides (1921–present) and her sister, Sylvia, found work at the Atlantic Parachute Company. When military service opened to women, Elgy signed up and served at Spence Army Air Field in Moultrie, Georgia. After the war, she was a civilian employee at Hanscom Air Force Base in Lexington, Massachusetts. (Courtesy of Elgy Tuory.)

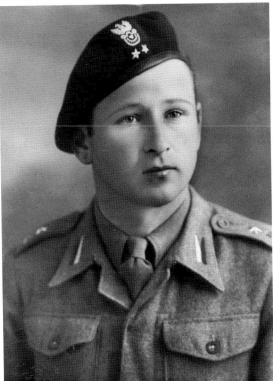

Tadeusz Rurak

Tadeusz Rurak (1913–2009) moved to Poland from his native Lowell at age nine when his family inherited a farm there. As a Polish army officer in 1939, he narrowly escaped the Katyn Massacre but was sent to Siberia by the Soviets. Released in 1942, he rejoined the Polish army and fought at Monte Casino. He returned to Lowell in 1948 and worked at Raytheon until his retirement, after which he devoted himself to community causes. (Courtesy of Ted Rurak.)

John G. (Jack) Flood

Enlisting in the US Army the day after he graduated from Lowell High in 1942, Jack Flood (1922–present) was assigned to the 899th Tank Destroyer Battalion as a scout in the reconnaissance company. As such, he often operated forward of friendly lines, trying to locate the German tanks that were the battalion's primary target. The 899th participated in nearly every major battle in the European Theater including the North African campaign, the invasions of Sicily and Italy, the invasion of Normandy, and the Battle of the Bulge. Jack was seriously wounded twice and was awarded the Silver Star, the Bronze Star, and numerous other decorations. After the war, he spent several decades as a mail carrier for the US Post Office and since retirement has devoted himself to St. Patrick's Parish, doing everything from sweeping the floors to ringing the bells. (Right, courtesy of Jack Flood; below, courtesy of RPH.)

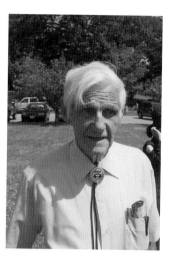

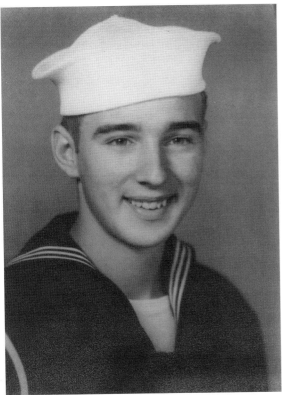

Norman Brissette

Enlisting in the Navy at age 17, Norman Brissette (1926–1945) became a gunner/radio operator on a SB2C Helldiver, flying from the carrier *Ticonderoga*. On July 28, 1945, his plane, piloted by Lt. Raymond Porter, was shot down off the coast of Japan. Both survived and were imprisoned with 10 other American flyers at the Hiroshima police station where they remained until August 6, 1945, when the Enola Gay dropped the atomic bomb less than a kilometer away. All but Brissette and one other died instantly. Ten days later, the newly captured crew of a downed B–29 was imprisoned with Brissette and the other survivor who were both gravely ill from radiation poisoning. Both died the next day, but the B–29 crew survived to relay their story. Brissette and the 11 other aviators are now memorialized by a plaque erected by the city of Hiroshima. (Both courtesy of Tony Archinski.)

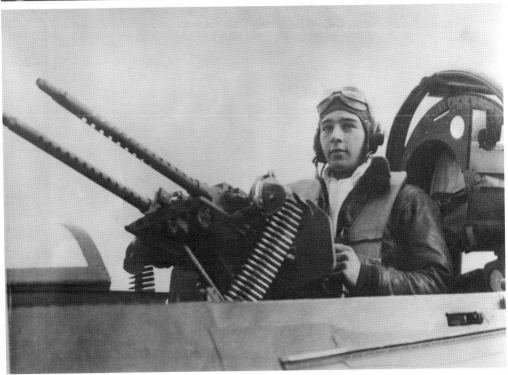

Edwin Poitras

When the call went out for volunteers who spoke French, Navy trainee Edwin Poitras (1922–2006) stepped forward. Schooled in clandestine radio procedures by the OSS, he parachuted into Normandy five weeks before D-Day to operate with the French Resistance where he survived frequent, often violent, contact with the Gestapo. For his heroism, he received the Navy Cross. He returned to Lowell where he worked for the city's Department of Public Works until his retirement. (Courtesy of Theresa Poitras.)

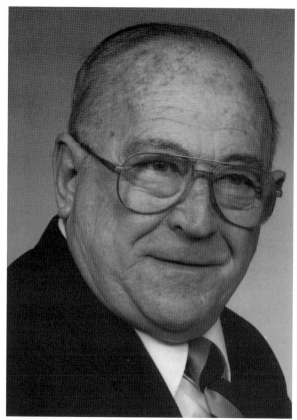

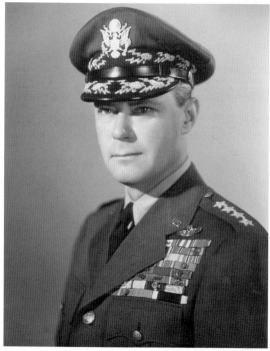

Hoyt Vandenberg

A graduate of Lowell High and West Point, Hoyt Vandenberg (1899–1954) became a senior commander in the Army Air Force during World War II. In 1946, President Truman appointed him director of the CIA, and in 1947, he became Air Force chief of staff, the position he held until illness forced his retirement in 1953. The Vandenberg Esplanade on the north bank of the Merrimack River is named in his honor. (Courtesy of Library of Congress.)

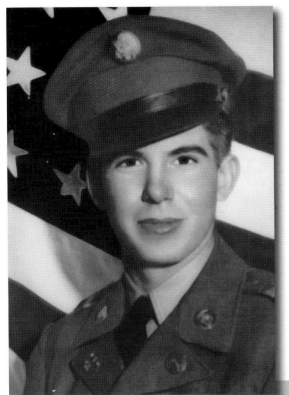

Joseph R. Ouellette
Cut off by the massive North Korean assault on the Pusan Perimeter, 20-year-old Pfc. Joseph R. Ouellette (1930–1950) of Lowell performed countless acts of extreme heroism that ensured the survival of his 2nd Infantry Division comrades but cost him his life. His posthumous Medal of Honor was presented to his mother by Gen. Omar Bradley. The City of Lowell renamed the Aiken Street Bridge in his honor. (Courtesy of Bob Page.)

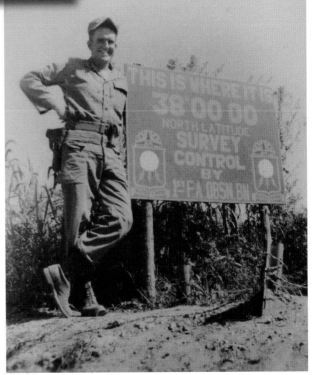

James E. Howe
After graduating from Tufts in 1952, James E. Howe went through Officer Candidate School in the Marine Corps and then served in Korea with the 1st Marine Division. He was one of many Lowellians, both World War II veterans and those too young for that war, to serve in Korea. This photograph was taken at the 38th parallel shortly after the end of hostilities. (Courtesy of Robert Howe.)

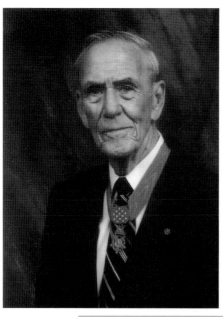

David McNerney

Growing up in Lowell, David McNerney's good nature won him many friends, but to the draftees he trained in 1965, he was an ornery first sergeant. When the men shipped out as Company A, 1–8 Infantry, 4th Infantry Division, McNerney joined them for his third tour in Vietnam. On March 22, 1967, the company was ambushed by a large North Vietnamese army unit in dense jungle in the central highlands. With all officers immediately killed or seriously wounded, McNerney took command. Years later, his men attributed their survival to his multiple acts of heroism, acts for which he was awarded the Medal of Honor, presented by Pres. Lyndon Johnson (below). Retiring after a fourth tour in Vietnam, McNerney began a second career as a US Customs Service inspector and frequently returned to Lowell to visit friends and family until his death in 2010. (Both courtesy of Kathleen Kress Hanson and Eileen Kress.)

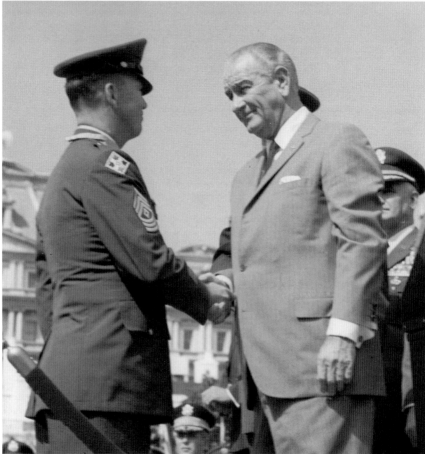

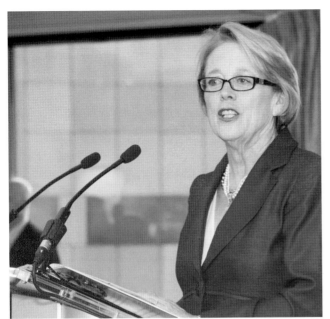

Niki Tsongas
The daughter of a career Air Force officer, Niki Tsongas (1946–present) has served on the House Armed Services Committee since she joined Congress in 2007; supporting military personnel and veterans have been her priorities. She has advocated better body armor, improved policies and protections for female service members, and more responsive VA services. Congresswoman Tsongas is the widow of Paul Tsongas who also represented Lowell in Congress. (Courtesy of Niki Tsongas.)

Lowell Veterans Council
Citizens of Lowell have served in the military in great numbers giving the city a large population of men and women who become involved in various veterans' organizations. Besides hosting ceremonies on Memorial Day and Veterans Day, veterans speak to students, provide color guards, assist at nursing homes and funerals, and participate in countless other events. Shown from left to right are Robert Casper, Ronald Roy, William Zuones, Robert Cronin, and Robert Page. (Courtesy of RPH.)

Scott Finneral

A Lowell native who enlisted in the Navy after graduating from Lowell High in 1988, Scottie Finneral and five comrades were killed when their MH-53 minesweeping helicopter plunged into the Persian Gulf on September 14, 1991, during the first Gulf War. In 1996, the Massachusetts state legislature named the walkway along the Merrimack River within the Lowell Heritage State Park the Scott Finneral Memorial Riverwalk. (Courtesy of Irene Finneral.)

Gold Star Wives and Mothers

The tradition of hanging a gold star in the window of the home of a service member killed in wartime gave rise to Gold Star organizations for wives, mothers, and family members to support those touched by wartime tragedy. Lowell has an active group of Gold Star Wives and Mothers who support each other and participate alongside veterans groups in civic ceremonies throughout the year. (Courtesy of Irene Finneral.)

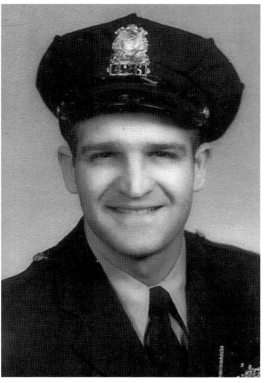

Christos G. Rouses
On the afternoon of November 17, 1978, Officer Chris Rouses (1925–1978), a well-liked and well-respected 23-year veteran of the Lowell Police Department, answered a silent alarm at Limby's Pharmacy on Branch Street. Confronting an armed robber, Officer Rouses was fatally shot. Other officers shot and killed his assailant. Officer Rouses, survived by his wife and three children, was the fourth Lowell police officer killed in the line of duty. (Courtesy of the Rouses family.)

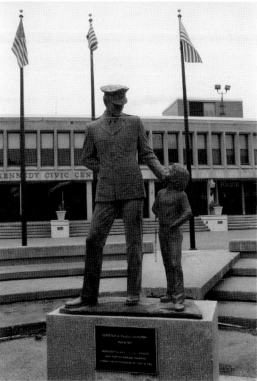

The Christos G. Rouses Memorial
The Christos G. Rouses Memorial, located on JFK Plaza in front of Lowell Police Department Headquarters and dedicated in 1980, memorializes four Lowell police officers killed in the line of duty: Patrick F. Leavitt who died on December 18, 1941; George F.A. Pearsall who died on April 24, 1957; John Joseph Winn who died on May 31, 1971; and Christos G. Rouses who died on November 17, 1978. (Courtesy of RPH.)

Kenneth Harkins

For nearly 50 years, "Harkins on Hurd for Homes" was the motto of the Hurd Street real estate office of Ken Harkins (1929–2010). A superb raconteur, Ken not only sold real estate but was also the region's best-known auctioneer. His true passion was helping others. Of all the local charities he supported, his favorite was the one he helped found—Remarkable, Active, Resilient Adults (RARA)—which assists developmentally disabled adults. (Courtesy of Kevin Harkins.)

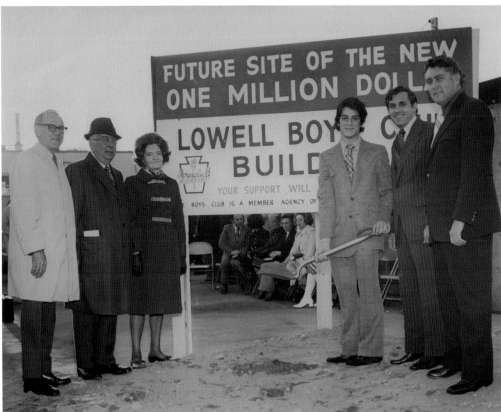

Boys and Girls Club of Greater Lowell

This photograph shows the October 25, 1972, ground breaking for the George A. Demoulas Building of the Boys and Girls Club of Greater Lowell on Middlesex Street. From left to right are Bill Vrettas, Bob Abbott, Mayor Ellen Sampson, Evan Demoulas (George's son), Julien LaCourse, and William King. The Demoulas family, founder of the Market Basket grocery chain, is a quiet benefactor of many community organizations and charities in Lowell. (Courtesy of Boys and Girls Club of Greater Lowell.)

Lura Smith
A New Orleans native, Lura Smith became assistant to the president of Middlesex Community College when her job at Wang Laboratories ended with the computer-maker's bankruptcy. In 1999, Smith organized a celebration of the life of Rev. Dr. Martin Luther King Jr. in Lowell, an event that has grown in size and scale each year. Her Lura Smith Scholarship Fund assists high school students from Lowell in attending Middlesex Community College. (Courtesy of Lura Smith.)

Amsi Morales
The gateway neighborhood of the Acre was saturated with violence, drugs, and poverty when Amsi Morales and her family arrived from Puerto Rico in 1986. Inspired by the hard work and activism of her mother, Amsi overcame these obstacles to graduate from college and law school. Grateful for a scholarship she received, Amsi created and fully endowed the Amsi Morales Scholarship and then founded the AMSI Foundation, which helps local students succeed in college. (Courtesy of Amsi Morales.)

Arthur Ramalho and William H. Hoar
The retired director of the Lowell Council on Aging, Arthur Ramalho (1935–present) has trained countless fighters at his West End Gym since it first opened in 1970. Bill Hoare (1932–2010), circulation manager of the *Lowell Sun*, was Golden Gloves New England tournament director for nearly 25 years. Through their involvement in boxing, Ramalho and Hoar devoted countless hours to the youth of Lowell. (Courtesy of Arthur Ramalho.)

Micky Ward (OPPOSITE PAGE)
Emerging from the rich tradition of boxing in Lowell, Micky Ward (1965–present) gained international fame with his three fights with Arturo Gatti in 2002 and 2003. His pre-Gatti professional career was the subject of the Academy Award–winning film *The Fighter*, in which Mark Wahlberg played Ward. Micky continues to live in Lowell and through his Team Micky Ward Charities provides financial assistance to children and families in need. (Courtesy of Micky Ward and Kevin Harkins.)

Frank Barrett
After half a century of mill closures, high unemployment, and neglected infrastructure, the Lowell City Council hired the local newspaper's city hall reporter to be Lowell's new city manager in 1953. During his nine years in that office, Frank Barrett propelled the city into the modern era, building schools and industrial parks, embracing federal funds for Urban Renewal projects, and raising the salaries and morale of municipal workers from their pre-Depression levels. (Courtesy of City of Lowell.)

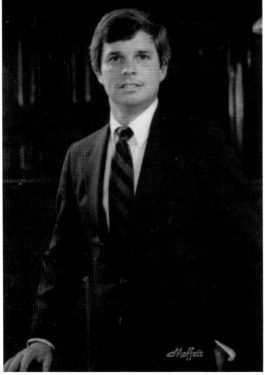

Brian Martin
A baseball star at Lowell High and UMass Amherst, Brian Martin has been a leader in Lowell's renaissance since his election to the city council in 1981. Over three decades he has served Lowell as mayor, city manager, athletic director at Lowell High, general manager of the Lowell Lock Monsters of the American Hockey League, and district director for Congresswoman Niki Tsongas. (Courtesy of Lowell Plan.)

Y2K Gathering of Elected Officials

As the 20th century came to a close, Mayor Eileen Donoghue invited past and present elected officials of the City of Lowell to gather at the Lowell Memorial Auditorium on December 29, 1999, to reflect on past accomplishments, share views on future progress, and receive the thanks of a grateful city for their service. From left to right are (first row) Richard Howe, Edward Early, Patricia Molloy, William Droll, Katherine Martin, George Kouloheras, Mayor Eileen Donoghue, Brendan Fleming, Robert Kennedy, Raymond Rourke, George Macheras, Kathy Kelly, and Connie Martin; (second row) Steven Gendron, Timothy Golden, Arthur Eno, Rita Mercier, Michael Geary, Armand Mercier, Gerald Durkin, Peter Richards, James McMahon, George O'Hare, William Taupier, William Martin, Brian Martin, John McQuaid, Arthur Gendreau, Edward Caulfield, Steven Panagiotakos, Rithy Uong, Raymond Riddick, Joseph Mendonca, George Anthes, Kevin McHugh, Larry Martin, Grady Mulligan, Thomas Casey, Brian Delaney, Edward Kennedy, Charles Caragianes, Tarsy Poulious, Curtis LeMay, Armand LeMay, Gail Dunfey, and Bernard Lemoine. (Courtesy of Eileen Donoghue.)

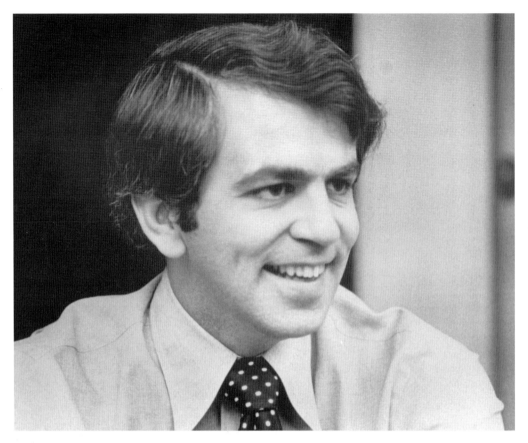

Paul Tsongas

The son of Greek immigrants, Paul Tsongas (1941–1997) graduated from Lowell High, Dartmouth, and Yale Law School. After service overseas with the Peace Corps, he returned to Lowell to successfully run for city council in 1969. In 1972, he was elected Middlesex County commissioner, and in 1974, he defeated Paul Cronin to win the Fifth Congressional District, making Tsongas the first Democrat to hold that seat in the 20th century. In 1978, Tsongas defeated Edward Brooke to win a US Senate seat in Massachusetts. Six years later, he stunned the nation by announcing that he would not seek reelection. He had cancer and wanted to spend his time treating it and being with his family. Eight years later with the cancer in remission, Tsongas returned to politics in a big way; he ran for president. After gaining early momentum with his blunt talk on the economy and the deficit, his victory in the New Hampshire primary was overshadowed by the second-place finish of Bill Clinton, who, because of early scandals that had jeopardized his candidacy, was labeled the "Comeback Kid" and went on to win the presidency. After dropping out of the presidential race, Tsongas cofounded the Concord Coalition, a political advocacy group that fought to end federal overspending. While traveling the country on behalf of the coalition in November 1993, Tsongas learned that the voters of Lowell had just replaced two-thirds of the nine-member city council. Seeing this as an opportunity to help the city emerge from a bout of economic and governmental stagnation, Tsongas plunged into local affairs and led the fight to construct a multipurpose arena and a minor league baseball stadium in the city; two projects that he believed would change the perception of the city. After a series of divisive council votes, both the ballpark and the arena became realities with the latter being named in honor of Tsongas. On January 18, 1997, Paul Tsongas died from side effects of his cancer treatments. He was 55. His brand of "liberalism that works" helped transform the Democratic Party, and his devotion to Lowell helped transform the city of his birth. (Courtesy of Niki Tsongas.)

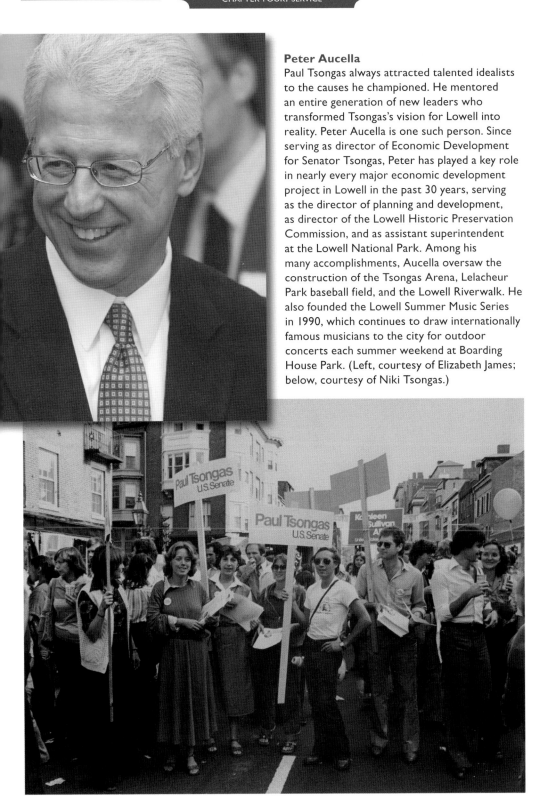

Peter Aucella

Paul Tsongas always attracted talented idealists to the causes he championed. He mentored an entire generation of new leaders who transformed Tsongas's vision for Lowell into reality. Peter Aucella is one such person. Since serving as director of Economic Development for Senator Tsongas, Peter has played a key role in nearly every major economic development project in Lowell in the past 30 years, serving as the director of planning and development, as director of the Lowell Historic Preservation Commission, and as assistant superintendent at the Lowell National Park. Among his many accomplishments, Aucella oversaw the construction of the Tsongas Arena, Lelacheur Park baseball field, and the Lowell Riverwalk. He also founded the Lowell Summer Music Series in 1990, which continues to draw internationally famous musicians to the city for outdoor concerts each summer weekend at Boarding House Park. (Left, courtesy of Elizabeth James; below, courtesy of Niki Tsongas.)

Theodore Edson

Born in Braintree, Theodore Edson (1793–1883) trained for the clergy at Phillips Andover and Harvard. Early in his career, Edson was invited by the founders of Lowell to become the rector of the newly constructed St. Anne's Episcopal Church, a position he held until his death 60 years later. His leadership on public education, his opposition to slavery, and his advocacy for the rights of workers often put him in opposition to his mill-owning congregants. (Courtesy of IHL.)

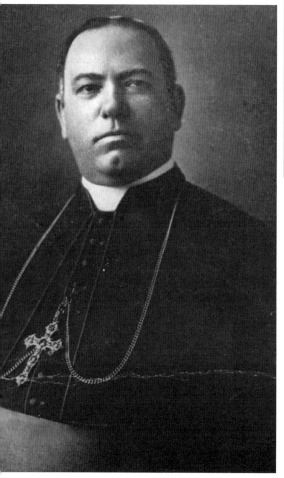

William Cardinal O'Connell

Born in Lowell to Irish immigrant parents, William Henry O'Connell (1859–1944) entered the priesthood after graduating from Boston College. He rose rapidly in the Catholic Church, becoming the second archbishop of Boston in 1907 and a cardinal in 1911. During his 36 years in charge of the Boston archdiocese, he oversaw the construction of numerous churches, schools, and hospitals and became a force in Massachusetts politics. (Courtesy of Dave McKean.)

CHAPTER FIVE

Culture

When Pat Mogan was growing up in Norwood in the years before World War II, he could never understand why his Irish neighbors tried so hard to erase their Irishness. He arrived in Lowell after the war, convinced that the city's ethnic diversity was a great resource. By exploring the food, dress, habits, and traditions of all the nationalities represented in Lowell, the city could become a great laboratory of education that created a civic vitality attractive to businesses and new residents. Mogan's vision is best seen in the exhibits and tours of the Lowell National Historic Park and during the last weekend in July, when the Lowell Folk Festival converts the downtown into an ethnic kaleidoscope of songs, sights, and smells.

Culture is also about art and literature, and Lowell has a long tradition of supporting both. When a young sign painter from Vermont named William Preston Phelps showed artistic promise, wealthy members of the community pooled funds to send him to Europe for two years of training. The Lowell Art Association, founded in 1878, is the oldest incorporated art association in the United States and has made its home in the birthplace of James McNeill Whistler since 1908. Lowell found an early literary voice in an unlikely place; the boarding houses of female mill operatives. In 1840, these young women, even after working 70 hours per week in the mills, still found time to write, edit, and publish their stories in the *Lowell Offering,* a journal that Charles Dickens declared "will compare advantageously with a great many English Annuals." Nearly 100 years later, Jack Kerouac's blue-collar pen found its rhythm writing about Lowell and went on to create an entirely new form of American literature.

When doctors and lawyers left downtown for the suburbs at the end of the 20th century, the city used innovative zoning provisions to transform vacant offices into live-work space for artists who flocked to the city in the face of soaring rents in Greater Boston. Anchored by downtown institutions such as the Lowell National Park, Middlesex Community College, and UMass Lowell, the city has latched onto the creative economy as a pathway out of the economic doldrums that plague so many post-industrial cities in America. Today, artists, writers, poets, musicians, and many others whose personal talent is their stock in trade live and work in Lowell, drawing visitors and changing the perception and the complexion of the city.

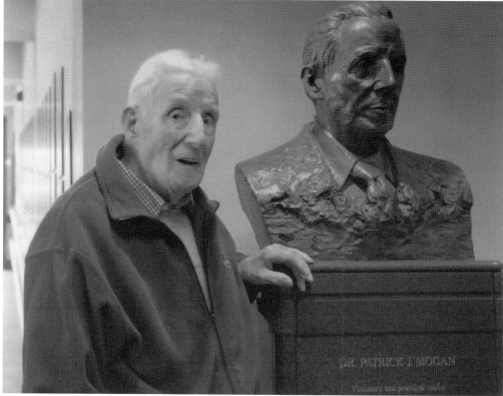

Patrick J. Mogan

Known as the father of the Lowell National Park, Pat Mogan (1918–2012) grew up perplexed that the Irish immigrants of his native Norwood shunned their heritage to blend in. Post–World War II, Mogan served as a teacher, principal, city school superintendent, and urban planner in Lowell. Gradually, he won converts to his view that the celebration of ethnic heritage and culture would empower residents, improve public education, and strengthen the community. (Courtesy of Meghan Moore/Megpix.)

F. Bradford Morse

Pat Mogan's persistence convinced Congressman Brad Morse (1921–1994), a former Lowell city councilor elected to Congress in 1960, to begin the process of making Lowell a national park. The efforts of Morse and his successors, Paul Cronin and Paul Tsongas, yielded in 1978 the Lowell National Historical Park, a federal installation that tells the story of industrialism in America while celebrating the culture and heritage of the people of Lowell. (Courtesy of RPH.)

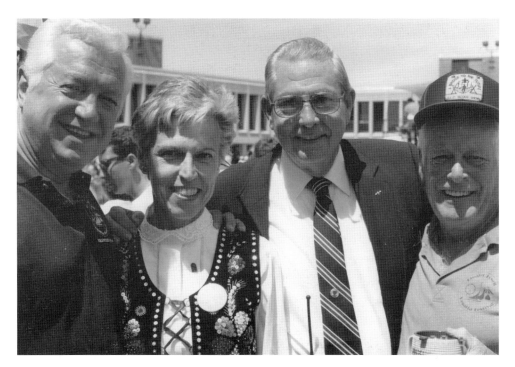

Regatta Festival Committee

While his Speare House restaurant was a great success, owner Zenny Speronis felt the adjacent Merrimack River was an underutilized civic resource. Gathering an eclectic mix of activists from Lowell's business and ethnic communities, he formed the Lowell Regatta Festival Committee, which held twice-yearly festivals on the riverbank and in downtown. From left to right are Zenny Speronis and fellow Regatta organizers Pauline Golec, John Green, and Richard Taffe. Together, they paved the way for the Lowell Folk Festival. (Courtesy of Pauline Golec.)

Susan Leggat

Sue Leggat (1947–2003) was a key figure in the transition from the Regatta to the Lowell Folk Festival. She was deeply involved in the Regatta Festival Committee, which later became the Lowell Festival Foundation. She then worked as the special events coordinator for the Lowell National Park where she helped organize the early folk festivals. (Courtesy of Janet Leggat.)

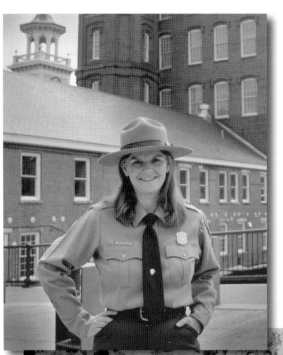

Chrysandra "Sandy" Walter
A California native and career National Park employee, Sandy Walter (1948–2011) was superintendent of the Lowell National Historical Park from 1984 until 1992. It was Sandy who coined the phrase "The park is the city and the city is the park" to describe the relationship between Lowell and the national park. Besides overseeing critical capital improvements, Sandy was instrumental in the early success of the Lowell Folk Festival. (Courtesy of Lowell National Historical Park.)

Lowell Folk Festival
On the last weekend of each July since 1987, downtown Lowell becomes home to the largest free folk festival in the United States. The Lowell Folk Festival features six outdoor stages on which folk musicians—ranging from Irish fiddlers to *a cappella* gospel singers—perform. Besides the music, there are street parades, dance parties, craft demonstrations, and dozens of food booths in which local ethnic organizations share their culinary heritage. (Courtesy of Kevin Harkins.)

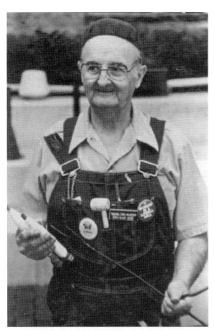

Camille J. Eno
After retiring from his small family printing business, Camille Eno (1917–2006) volunteered at the Lowell National Park and at the Lowell Folk Festival, working as a greeter while dressed in the type of clothes he once wore as a pre-teen mill worker in Lowell. (Courtesy of Leon Eno.)

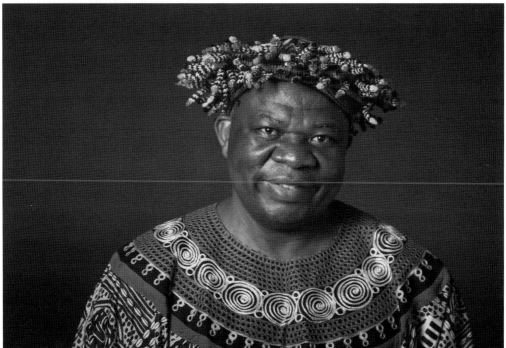

Fru Nkimbeng
A native of Cameroon, Fru Nkimbeng came to America in 1985 to attend Roxbury Community College. He settled in Lowell in that same year and has worked ever since as an information technology engineer. In 2000, Fru helped found the Lowell African Festival and served as president of the African Cultural Association for six years. (Courtesy of Adrien Bisson.)

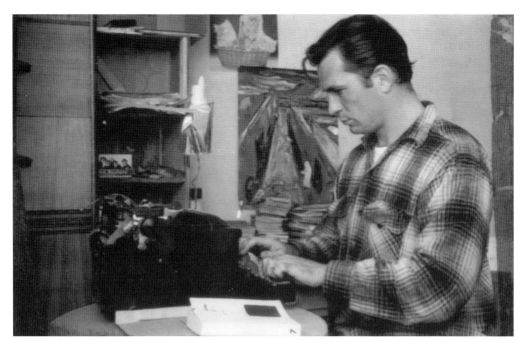

Jack Kerouac

The son of a French Canadian printer and the star of Lowell High's football and track teams, Jack Kerouac (1922–1969) perfectly captured the life and language of Lowell in his early novels. *On the Road*, published in 1957, added a new voice to the country's literary mix and helped launch the upheaval of values in 1960s America. His grave, his hangouts, and his memorial draw countless admirers to Lowell each year. (Courtesy of Orange County Historical Society.)

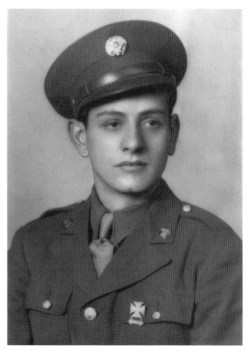

Sampatis G. Sampatacacus

An aspiring actor and poet also known as Sam, Sammy, and Sebastian, Sampatis (1922–1944) was a companion and formative influence on Jack Kerouac, who described Sam in *Vanity of Duluoz* as "a great kid, knightlike, i.e., noble, a poet, goodlooking, crazy, sweet, sad, everything a man could want in a friend." Sam enlisted in the US Army in 1942, was mortally wounded in Italy, and died in a field hospital in North Africa in 1944. (Courtesy of Betty Sampas.)

Paul Marion

Paul Marion read poems from his book *Strong Place* (1984) to a full house at Merrimack Repertory Theatre at a literary event headlined by poets Allen Ginsberg and Gregory Corso and organized by Brian Foye and friends to benefit the new Corporation for the Celebration of Jack Kerouac in Lowell (now Lowell Celebrates Kerouac! Inc.) on March 17, 1986. Paul continues to have a profound influence on cultural life in Lowell. (Courtesy of Jim Higgins.)

Bob Martin

A self-taught musician who composed songs in his head while painting houses, Bob traveled to Nashville in 1972 and soon recorded his first folk album. Performing across the country, he has opened for Joan Baez, Richie Havens, Stevie Nicks, and many more. In two recent European tours, Bob performed in the Netherlands, Belgium, France, and Ireland. Lowell and its stories flow through his songs. (Courtesy of Bob Martin.)

Mary Boutselis Sampas and Charles G. Sampas

As a student at Lowell High, Mary Boutselis (1917–2011) began a newspaper career that spanned 75 years. While writing thoughtful columns about local events under pseudonyms such as Pertinax and Gal Friday, she met and married respected *Lowell Sun* newspaper writer Charles Sampas (1911–1976). When Sampas was dispatched to Europe to cover President Kennedy's meetings with DeGaulle and Khrushchev, Mary accompanied him and wrote her own amazing pieces from the field. She also covered Jackie Kennedy in Greece and wrote articles from Hong Kong and Singapore. For all their travels, they wrote mostly about Lowell. His *Sampascoopies*, a daily 1,000-word column of news, gossip, culture, and history, left a rich record of the city's history. Still writing into her 90s, Mary dictated her final column from her hospital bed just days before she died. (Both courtesy of Marina Sampas Schell.)

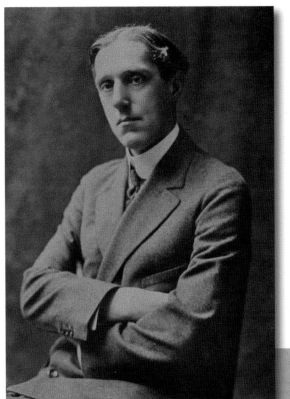

Frederick W. Coburn
A graduate of Lowell High and Harvard, Frederick Coburn was an artist and art critic who wrote for the *Nation*, *Atlantic Monthly*, and newspapers such as the *Boston Herald* and the *Lowell Courier Citizen*. A member of the Lowell Art Association, he helped save the Whistler House and convert it into an art museum. He was also the author in 1920 of the three-volume *History of Lowell and Its People*. (Courtesy of MC.)

George F. Kenngott
While pastor of Lowell's First Trinitarian Church from 1892 to 1912, George Kenngott earned his Ph.D. at Harvard. Notwithstanding its ethnic and class slant, his published dissertation, *The Record of a City: A Social Survey of Lowell Massachusetts*, remains a valuable resource that thoroughly documents conditions at a time when the rapid influx of immigrants from Eastern Europe and the Mediterranean changed much about the city. (Courtesy of IHL.)

Catherine Goodwin

Catherine Goodwin (1922–2011) introduced generations of Lowellians to the city's history in countless ways, from staging exhibits of artifacts at the Lowell Museum to overseeing the 100th Anniversary celebration of the Whistler House Museum of Art. Catherine was perhaps best known for her walking tours of Lowell Cemetery, which she conducted for more than 30 years. A constant theme of hers was a realistic portrayal of the role and accomplishments of women in Lowell. (Courtesy of Marie Sweeney.)

Louisa Maria Wells

Louisa Wells (1817–1886) came to Lowell from Vermont as a teenager to work at the Lawrence Manufacturing Company. With no spouse, children, or siblings, she willed her entire estate to be used to construct a monument at her grave in Lowell Cemetery. After a will contest that took 20 years to adjudicate, her executor hired noted sculptor Evelyn Longman to create the monument, which depicts a mill worker and an angel. (Courtesy of RPH.)

Samkhann Khoeun and Venerable Ly Van

When Samkhann Khoeun (right) moved from his adopted home in Chicago to Lowell to serve as the executive director of the Cambodian Mutual Assistance Association, he began attending the Glory Buddhist Temple and there met the Venerable Ly Van (below, 1917–2008), a Theravada Buddhist Monk who had survived the Killing Fields and had been among the first Cambodian refugees to arrive in Lowell in the early 1980s. After the monk passed, Samkhann discovered some loose-leaf pages written in Khmer among Ly Van's possessions. It was an epic poem in which Ly Van described his harrowing escape from his home in Battambang Province across the mountains on the Thai border. As a survivor of the Killing Fields himself, Samkhann recognized this as a unique piece of Cambodian historical writing and published it in 2010 as *O! Maha Mount Dangrek*. Printed in both Khmer and English, the book gives Cambodian Americans a rare, first-person account of the story of their people. (Both courtesy of Samkhann Khoeun.)

Angelo "Angie" Bergamini

The son of a bricklayer from Italy who settled in Lowell for construction work, Angie Bergamini (1928–1997) grew up in a house filled with music. He played his entire life and in 1972 formed the 12-piece Angie Bergamini Orchestra, which kept big band music alive in New England. One of Angie's last performances was on New Year's Eve in 1996 at the Lowell Hilton, where he was joined on stage by his son Andrew (right) and grandson Daniel (left). (Courtesy of Andrew Bergamini.)

Carl Braun Jr.

After graduating from Lowell High in 1905, Carl Braun Jr. (1886–1971) joined the Salem, New Hampshire–based family business, Canobie Lake Park. In 1924, he bought a roller-skating rink on Thorndike Street in Lowell and renamed it the Commodore Ballroom. During its 48 years of operation, the Commodore hosted the top acts in America including Louie Armstrong, Duke Ellington, the Dorseys, Glen Miller, Frank Sinatra, Cream, Rod Stewart, and the Byrds. (Courtesy of Lowell High School.)

Ed McMahon

Ed McMahon's first job after Lowell High was at radio station WLLH, which he visited during a 1994 stop in Lowell (above left with Mayor Richard Howe). Best known for the 30 years he spent booming out "Heeeere's Johnny" on the *Tonight Show*, McMahon also flew scores of combat missions as a Marine aviator in World War II and Korea. When offered a monument in Lowell, he chose a bench so people "could rest their weary bones." (Courtesy of Kevin Harkins.)

Paul Sullivan

Although he reached the pinnacle of the talk radio world with his evening show on WBZ, folks in Lowell will always remember Sullivan as the host of *Morning Magazine* on local radio station WLLH. Sullivan and his friendly competitors at WCAP made local radio mandatory listening for those seeking politics and entertainment in Greater Lowell. He used humor and irreverence to make hyper-local stories interesting to everyone in the region. He died of cancer in 2007. (Courtesy of RPH.)

Israel "Ike" Cohen and WCAP

Israel "Ike" Cohen's love of radio was born delivering newspapers to the Portsmouth Naval Yard in the years after World War I. His teenaged bedroom was soon filled with wet cell batteries, telegraph units, and primitive radio sets, making it a gathering place for neighbors of all ages who lacked this new technology. Ike became a radio officer on a passenger liner but dreamed of running his own radio station. Joined by his business-minded brother Maurice, the Cohens launched WCAP in Lowell on June 10, 1951. The brothers brought many innovations to local radio including remote broadcasts and listener call-in shows such as Telephone Trading Time, a type of pre-Internet Craigslist that often left the city's telephone circuits jammed due to the volume of calls. The photograph below shows a WCAP remote broadcast from Pollards Department Store. (Both courtesy of Maurice Cohen.)

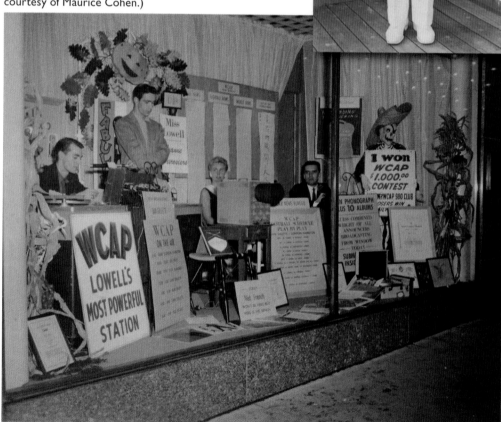

Israel "Ike" Cohen and Maurice Cohen
With innovative programming, a thirst for news, and keen business sense, the Cohen brothers made WCAP a force in politics, news, and commerce in the Merrimack Valley. Their commitment to local radio was evident in 2007 when Maurice, forsaking more lucrative offers from corporate entities that would have homogenized programming, sold the station to a group led by Lowell native Sam Poulten, who has continued the Cohens' commitment to the community. (Courtesy of Maurice Cohen.)

Sam Poulten
A lieutenant colonel in the Army Reserve with multiple deployments to the Iraq Theater, Sam Poulten has served his native Lowell as an educator, a realtor, a political activist, and a leader in community support for veterans and their families. In 2007, he led a group that purchased radio station WCAP and kept its programming local, providing a strong, stable voice in the increasingly fragmented world of the media. (Courtesy of Sam Poulten.)

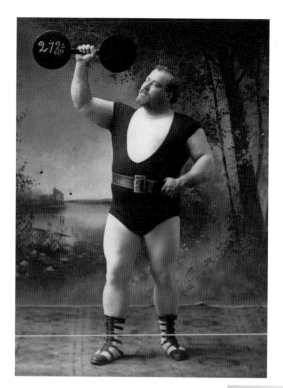

Louis Cyr
Born in Quebec as Cyprien-Noe Cyr (1863–1912), he came to Lowell with his family at age 15, changed his name to Louis, and began entering strongman competitions. His many feats—lifting 500 pounds with three fingers and carrying 4,337 pounds on his back—suggest Cyr was the strongest man who ever lived. Eventually, he left Lowell to work as a police officer in Montreal while continuing to entertain as a strongman. (Courtesy of Guy Lefebvre.)

William H. "Billy" Merritt
Bill Merritt (1870–1937) played ball in Lowell but it was at Holy Cross College that his talent emerged. After graduation, he had a nine-year professional career, playing catcher for a number of teams, including the 1893 National League champion Boston Bean Eaters. The *New York Clipper* newspaper of February 25, 1893, wrote of Merritt: "He faces pluckily the swiftest and wildest pitching, and promises to excel as a catcher." (Courtesy of Margaret Merritt Loucraft.)

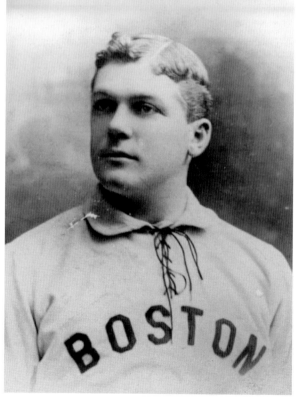

John "Texas Jack" Omonhundro and Giuseppina Morlacchi

Working alongside William "Buffalo Bill" Cody, John Omonhundro (1846–1880), known as "Texas Jack," became a top Army scout in the American West and a lead character in the wildly popular dime novels of Ned Buntline. When Buffalo Bill and Texas Jack joined Buntline's stage play, *Scouts of the Prairie*, Giuseppina Morlacchi (1843–1886), a classically trained ballerina from Italy, was hired by Buntline to play the "Indian maiden." The show was a sensation, and Jack and Giuseppina, known as "The Peerless Morlacchi," married and returned to her farm in Billerica. Drawn to Lowell, they purchased a home at Market and Suffolk Streets. Omonhundro died while visiting Colorado, while Giuseppina died in Lowell. The photograph to the right shows, from left to right, Texas Jack, Wild Bill, and Buffalo Bill. The photograph below shows Guy Lefebvre, proprietor of the Lowell Gallery and foremost authority on Lowell and the American West, at Giuseppina's grave in St. Patrick's Cemetery. (Both courtesy of Guy Lefebvre.)

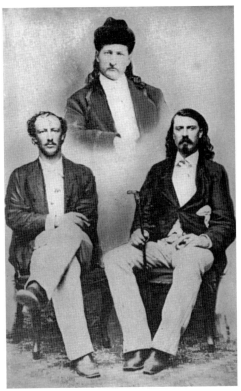

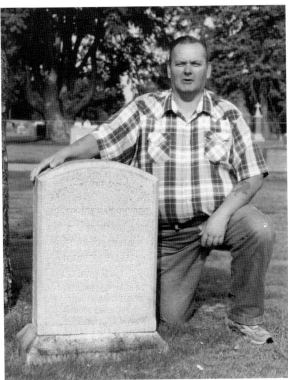

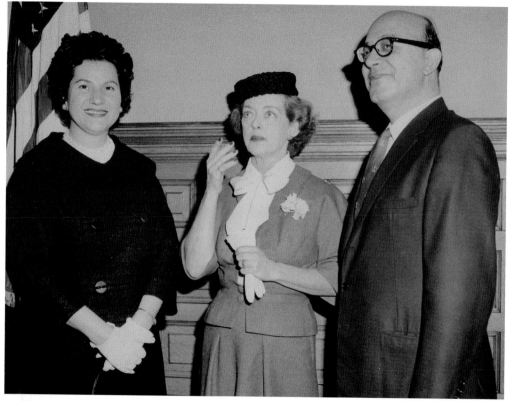

Ruth Elizabeth "Bette" Davis
Born on Chestnut Street in Lowell, Bette Davis (1908–1989) moved to New York City
with her mother and younger sister in 1921 after her parents divorced. Eventually, she
moved to Hollywood for a career in film. She won Academy Awards for Best
Actress in 1935 for *Dangerous* and in 1938 for *Jezebel*. Davis returned
to Lowell several times, once accompanied by Charles and Mary
Sampas to pick up her birth certificate at city hall. (Courtesy of
Marina Sampas Schell.)

James McNeill Whistler
Son of the chief engineer of the Lowell Machine Shop, James McNeill
Whistler (1834–1903) was born in the family home at 243 Worthen
Street. He achieved great fame as an artist, but he never showed
affection for Lowell. In 1908, his birthplace became home of the
Lowell Art Association and now houses the Whistler House
Museum of Art. A statue of Whistler sculpted by Mico Kaufman
stands on the grounds of the museum. (Courtesy of Whistler
House Museum of Art; photograph by RPH.)

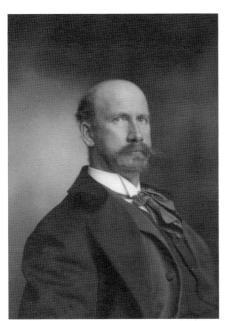

William Preston Phelps

Coming to Lowell as a teenaged sign painter, William Preston Phelps (1848–1923) painted local landscapes in his spare time. His evident talent inspired prominent Lowellians to finance two years of study by Phelps in Munich where he specialized in painting scenes of nature. He returned to Lowell, but after inheriting a family farm in Chesham, New Hampshire, he moved there in 1888 and concentrated on painting nearby Mount Monadnock. (Courtesy of Carol Patnaude and Barbara Sharp.)

Elizabeth Morse Walsh

A graduate of the Lowell public schools, Elizabeth Morse Walsh (1886–1983) trained at the Museum of Fine Arts in Boston where she won a scholarship to study in Europe. After two years in Paris, she returned to Lowell in 1924 and exhibited her European work at the Museum of Fine Arts and at Lowell's Whistler House. Walsh specialized in portrait painting and completed more than 150 works throughout her career. (Courtesy of Elisabeth Byers.)

Janet Lambert Moore

A graduate of Lowell High and Massachusetts College of Art, Janet Lambert Moore is one of Lowell's best-known artists. She exults that advances in color printing now make her work available to a wide audience. For half a century, her tireless participation in exhibits, fairs, and festivals helped keep the Lowell art scene vibrant, and generosity with her time and talent has provided invaluable support to many non-profits in the city. (Courtesy of Janet Lambert Moore.)

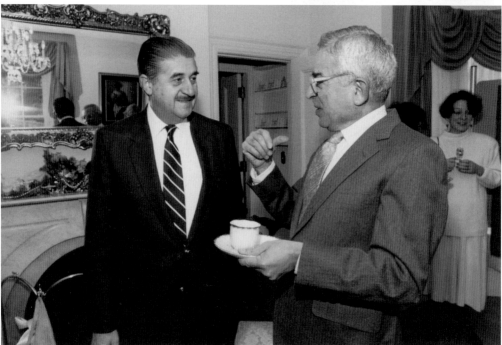

Vassilios "Bill" Giavis

Inspired by a talented brother to attend Massachusetts College of Art, Bill Giavis (left) put his painting career on hold for three decades to work in the family store in the Acre. Selling the store in the early 1980s, he resumed painting and helped found the Brush Art Gallery. He has a passion for Lowell, which he tries to preserve and share in his paintings. (Courtesy of Kevin Harkins.)

Grady Mulligan

After graduating from Lowell High, Grady Mulligan (1957–2002) (left) moved to New York City and sang both on and off Broadway. Returning to Lowell in the early 1990s, he was elected to the city council. Working with former senator Paul Tsongas (right) Grady was an early advocate of the cultural economy. Exceedingly generous of his time and talent, Grady showed great courage in his votes and in his 20-year battle with AIDS. (Courtesy of Mary Howe.)

Nancy Donahue

Spouse of prominent attorney Richard K. Donahue (left) and mother of 11, Nancy Donahue (right) has been Lowell's leading philanthropist and patron of the arts for decades. She was the first president of the Merrimack Repertory Theatre and has long been involved in leadership roles in the Whistler House Museum of Art, the New England Quilt Museum, and many other cultural and community organizations in Lowell. (Courtesy of Kevin Harkins.)

Andy Jacobsen and Brew'd Awakening Coffeehaus

When Andy Jacobsen opened Brew'd Awakening Coffeehaus on Market Street in 2005, he sought to create a place where people could meet, hang out, and relax. He succeeded, attracting a diverse clientele that creates a synergistic buzz in and around the shop. With frequent poetry readings, live music performances, and displays of locally produced art—not to mention superb coffee—Brew'd Awakening has become a hub of Lowell's creative economy. (Left, courtesy of Andy Jacobsen; below, courtesy of Tory Germann.)

Charles Cowley

Charles Cowley (1835–1908) was many things: a newspaper editor, a Naval officer, a prominent lawyer, a member of the Lowell School Committee, and a reformer. He was also a prolific writer best known for his 1868 *History of Lowell*. Of the people who came to Lowell, he wrote: "They constituted from the outset an aristocracy of talent such as now would hardly be assembled in a single city." (Courtesy of IHL.)

Rita Savard

A graduate of Emerson College, Rita Savard left her job as a reporter at the *Lowell Sun* to found *Howl in Lowell*, a nonprofit web-based multimedia magazine that connects its readers to the art, music, and events that are transforming the city of Lowell into a regional leader in the creative economy. Rita Savard and other entrepreneurs and experimenters are using new media tools and techniques to capture the history of Lowell in the 21st century. (Courtesy of Tory Germann.)

INDEX